AuthorHouse™
1663 Liberty Drive
Bloomington, IN 47403
www.authorhouse.com
Phone: 1 (800) 839-8640

Published by AuthorHouse 12/18/2015

ISBN: 978-1-5049-6014-4 (sc)
ISBN: 978-1-5049-6013-7 (e)

Library of Congress Control Number: 2015918406

Print information available on the last page.

Any people depicted in stock imagery provided by Thinkstock are models,
and such images are being used for illustrative purposes only.
Certain stock imagery © Thinkstock.

This book is printed on acid-free paper.

Because of the dynamic nature of the Internet, any web addresses or links contained
in this book may have changed since publication and may no longer be valid. The views
expressed in this work are solely those of the author and do not necessarily reflect the
views of the publisher, and the publisher hereby disclaims any responsibility for them.

Even More Cartoons:
Cats & Dogs & Other Creatures
by Bernard Schoenbaum

Compiled by Rhoda A. Schoenbaum & Laura Schoenbaum

authorHOUSE®

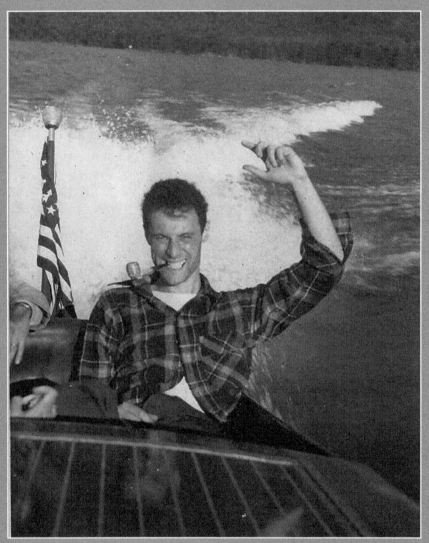

Photo of Bernard Schoenbaum on Lake George, New York 1948

Foreword

As I noted in our previous volume, Bernard Schoenbaum's cartoons have been published worldwide but upon his death, hundreds of unpublished cartoons were found in his files.

To distinguish them from the already published cartoons, my daughter Laura, a graphic designer, and I have organized them and compiled some of them into the group included in this publication with the title of **Even More Cartoons: Cats & Dogs & Other Creatures** as our previous collection was **More Cartoons: Men & Women & Children**.

So here you have even more of them.

Hope they bring even more smiles!

Rhoda A. Schoenbaum
2015

Book design by Laura Schoenbaum

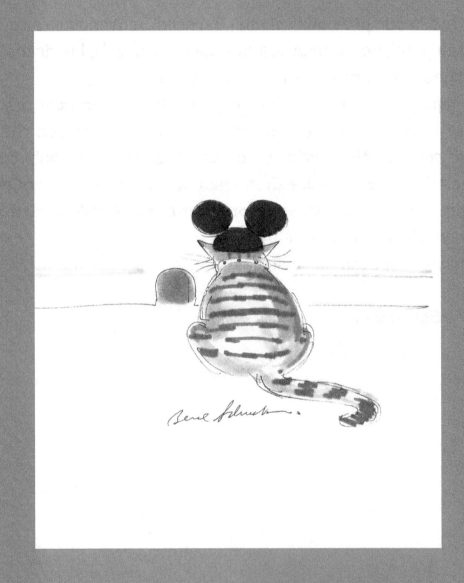

Cats

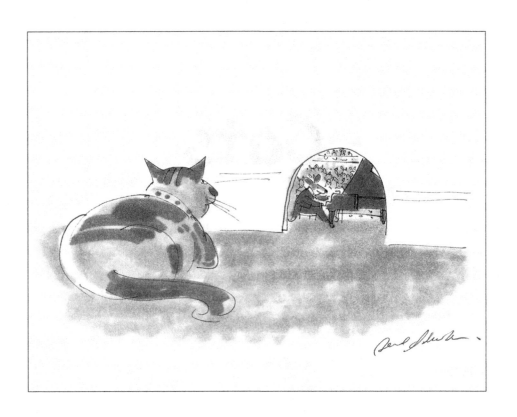

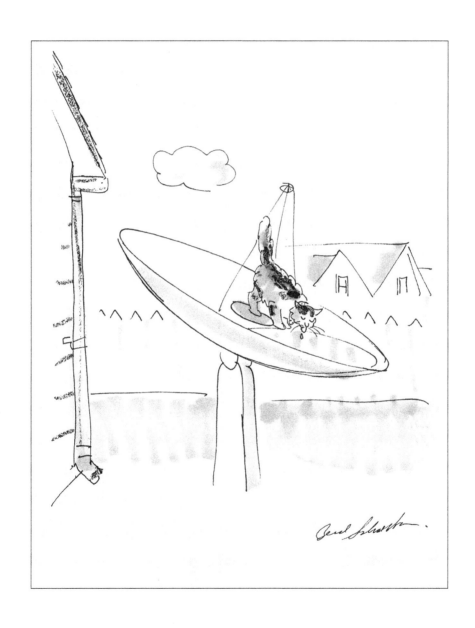

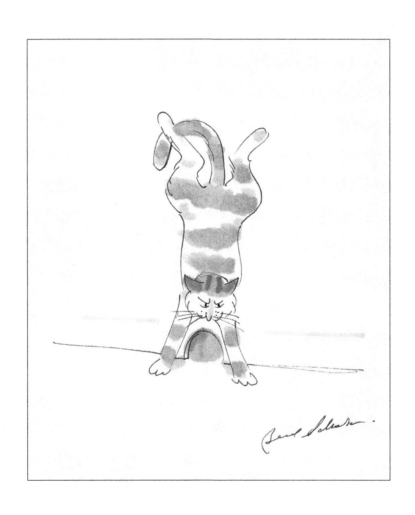

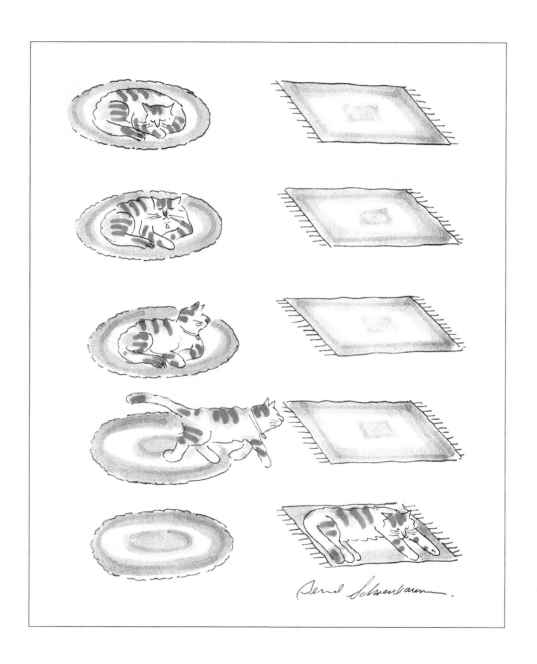

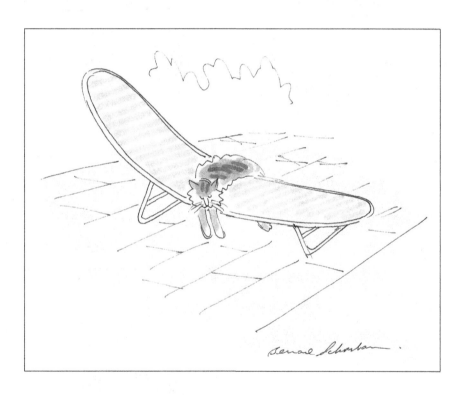

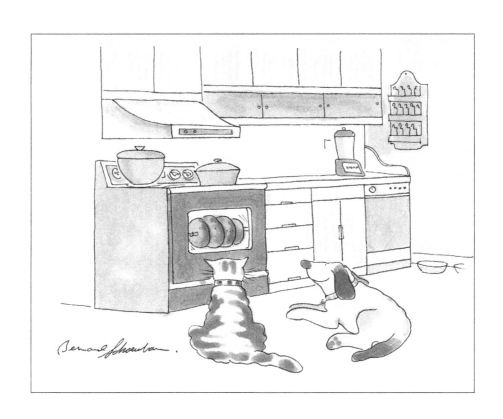

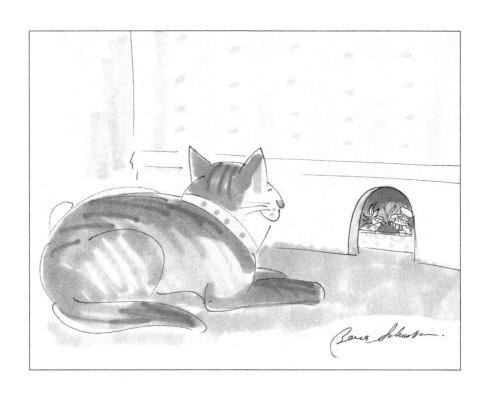

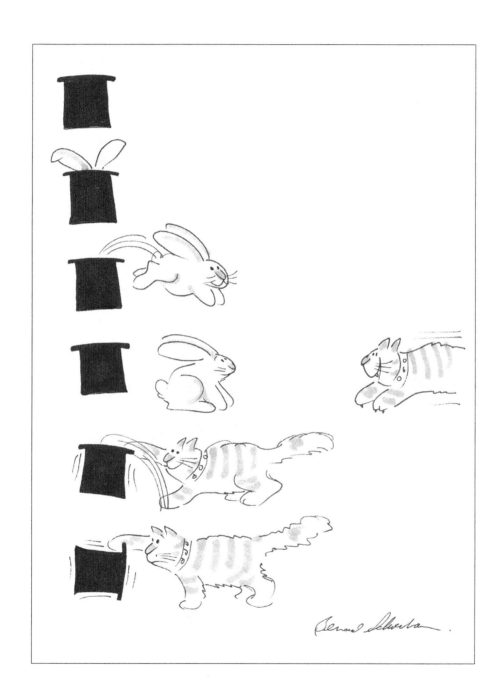

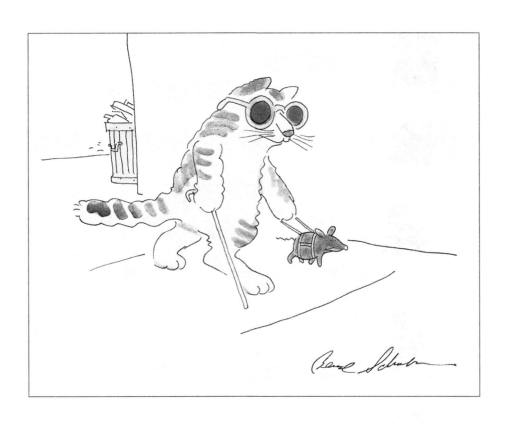

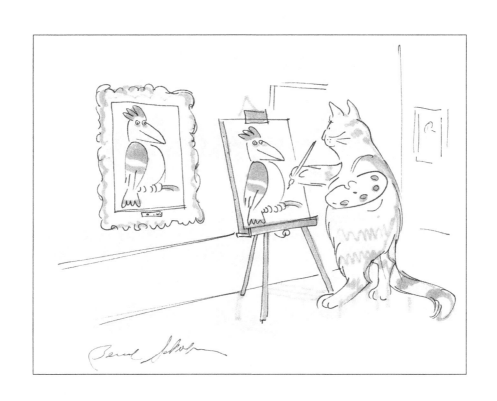

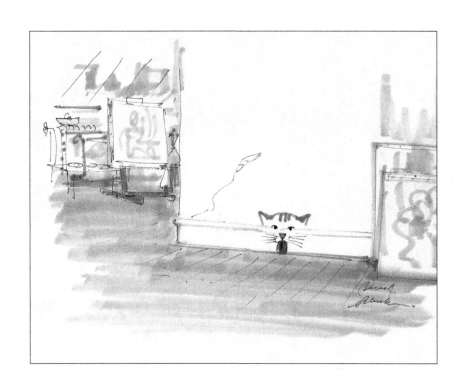

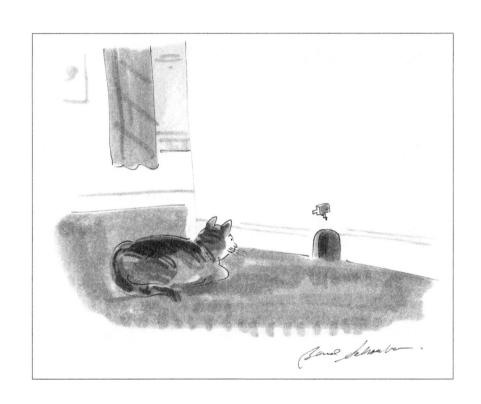

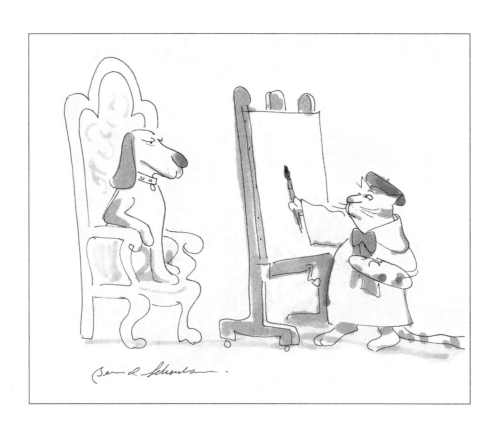

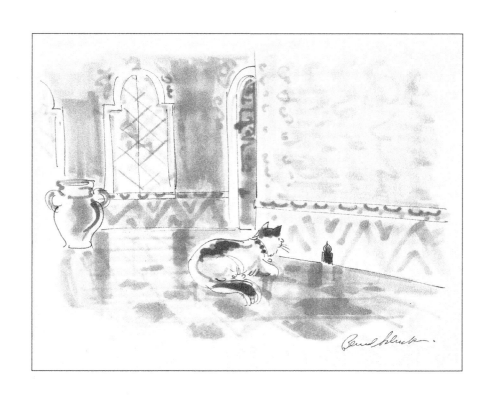

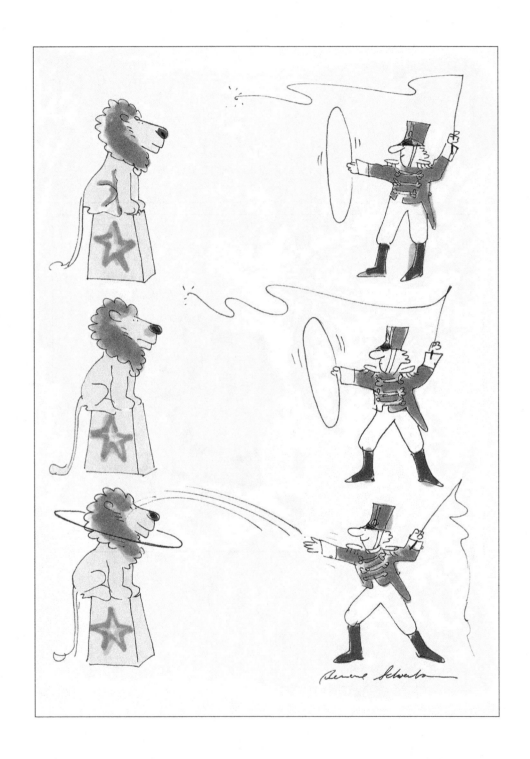

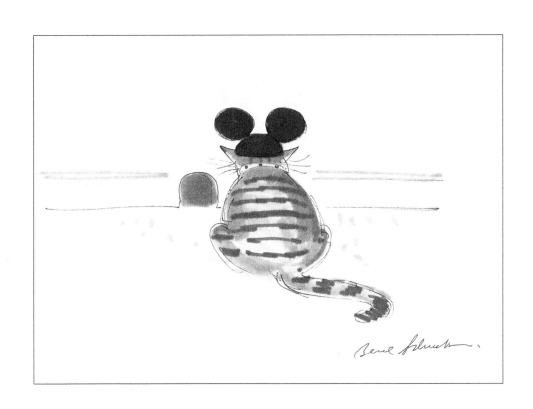

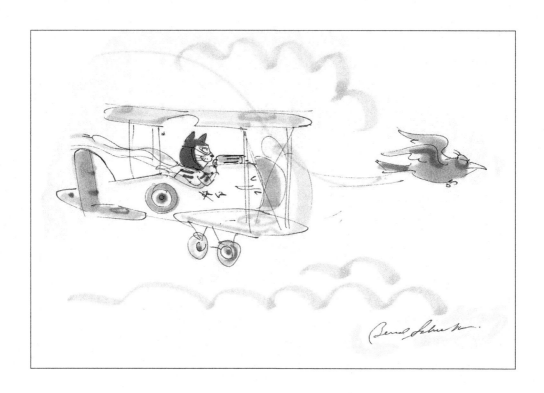

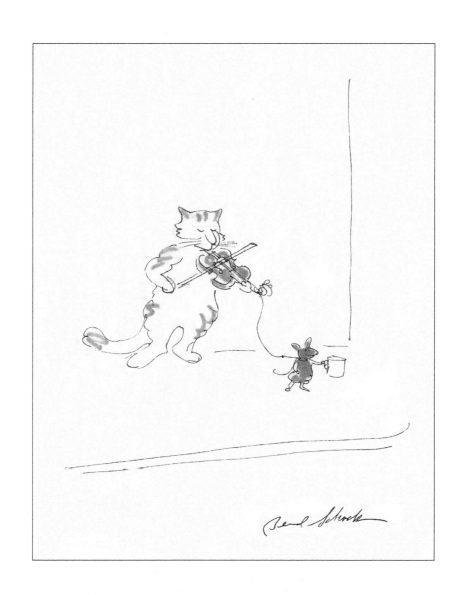

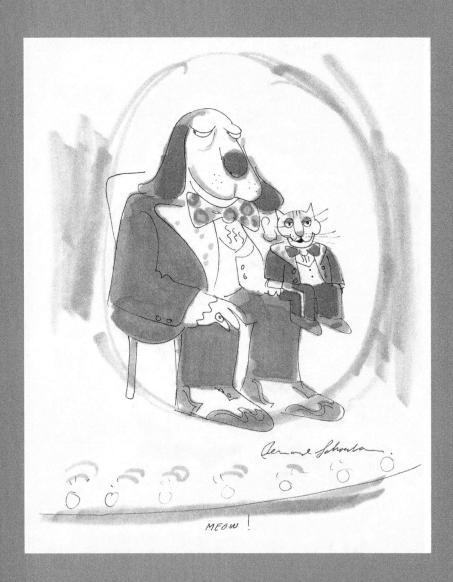

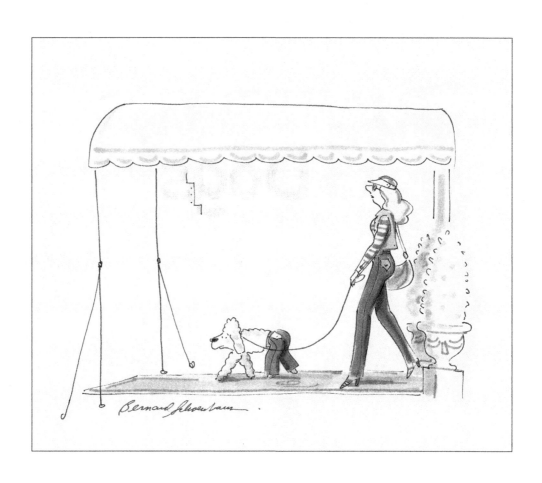

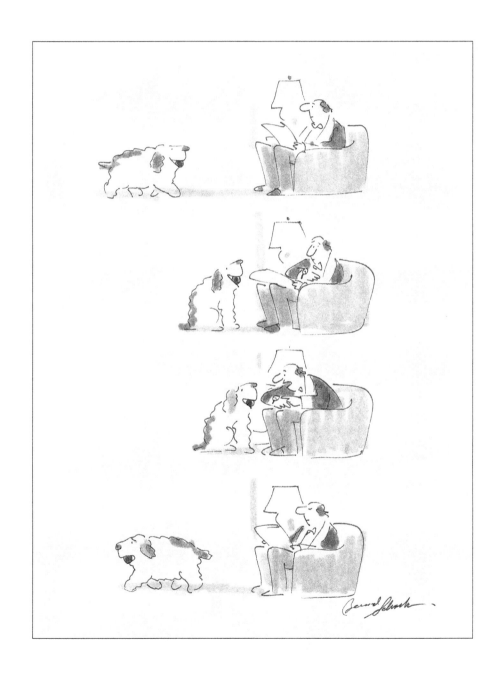

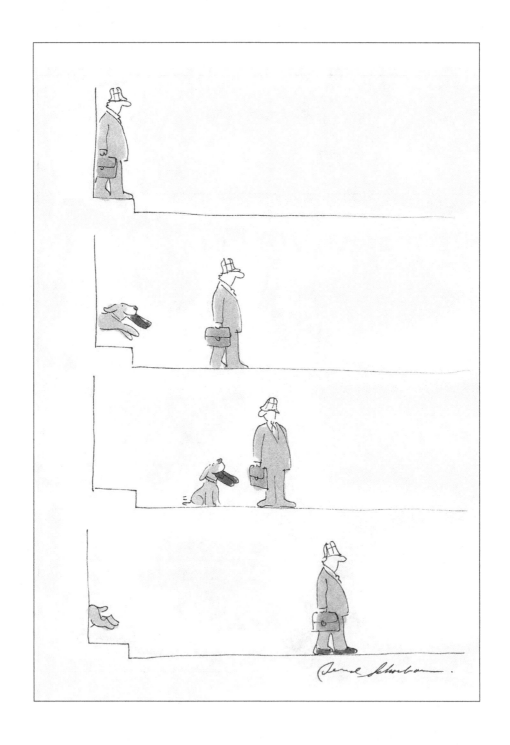

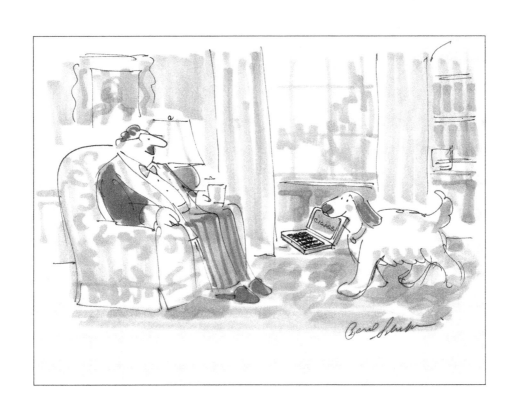

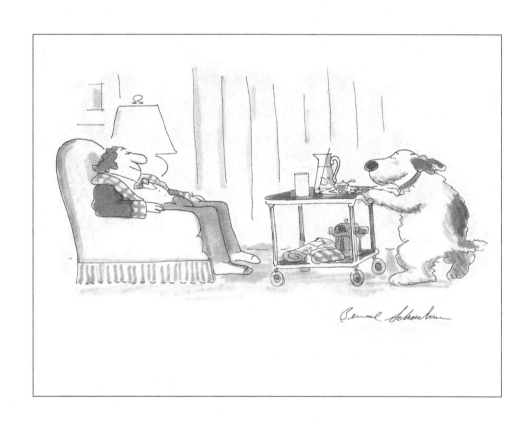

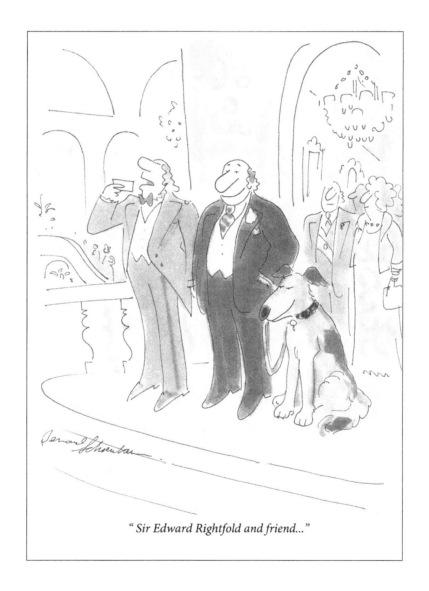

" *Sir Edward Rightfold and friend...*"

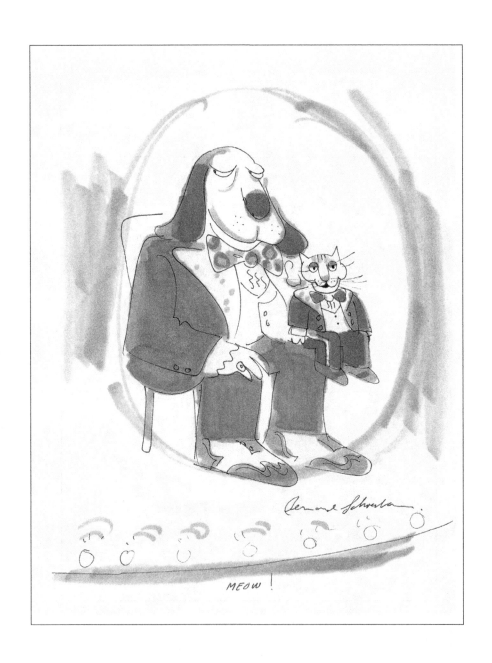

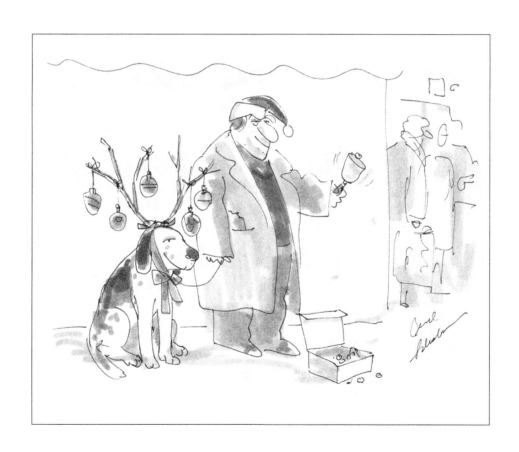

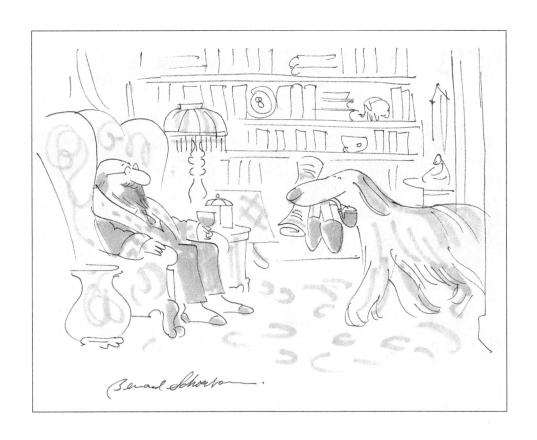

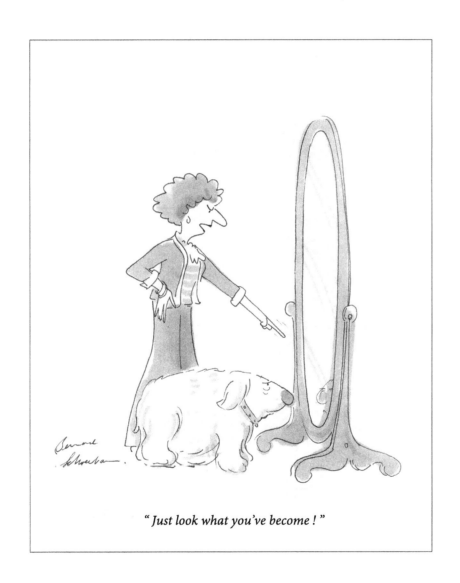

" *Just look what you've become !* "

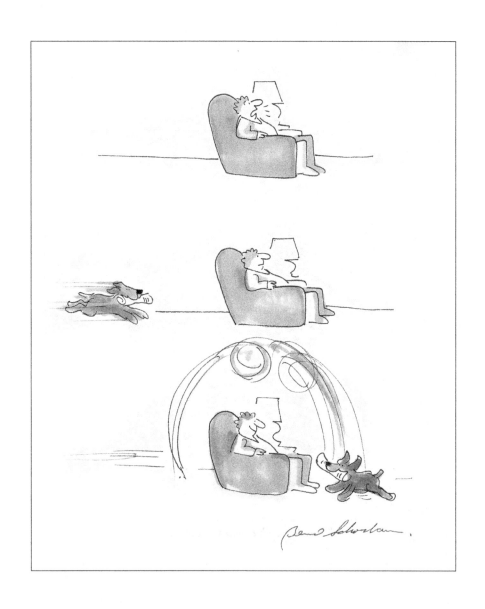

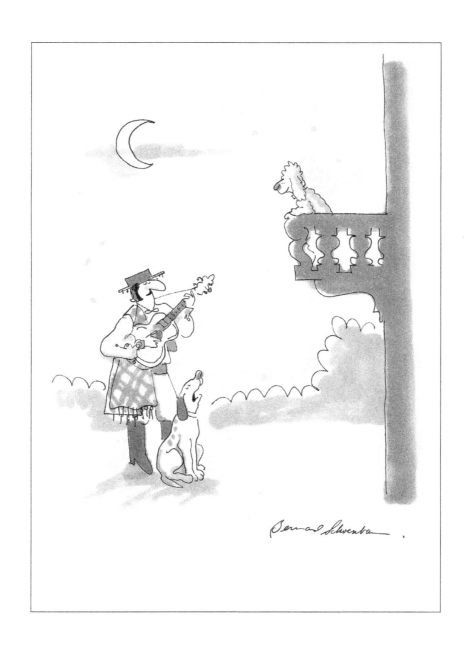

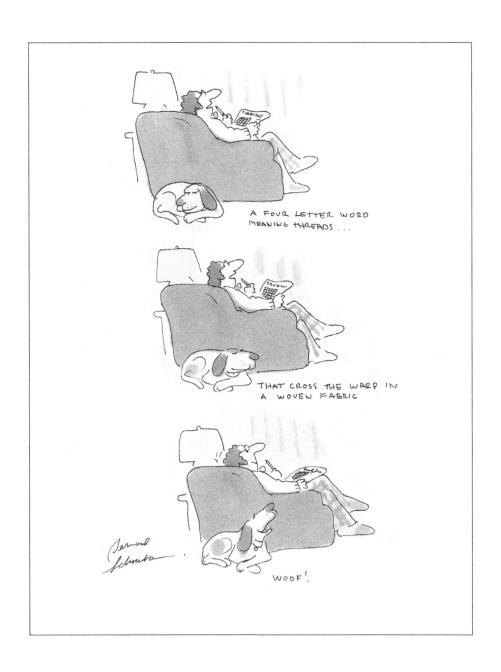

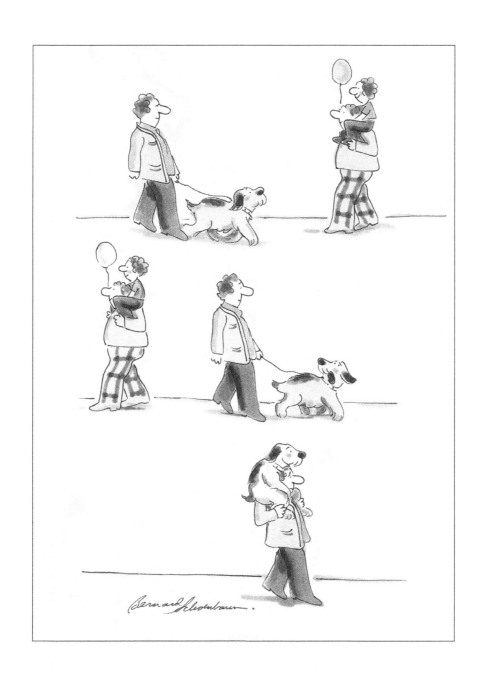

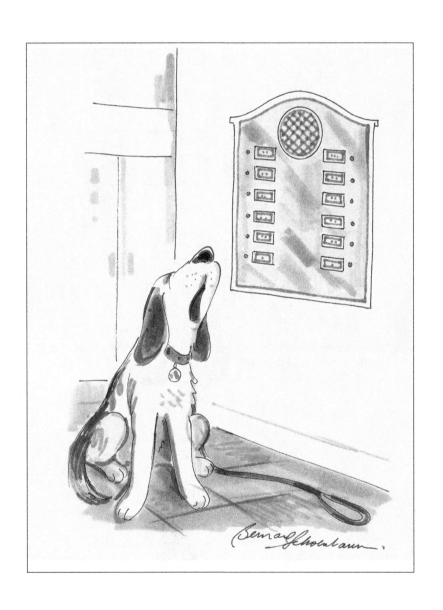

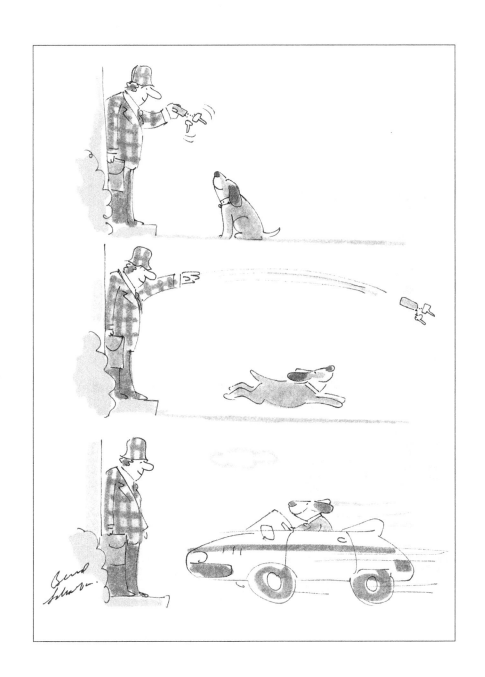

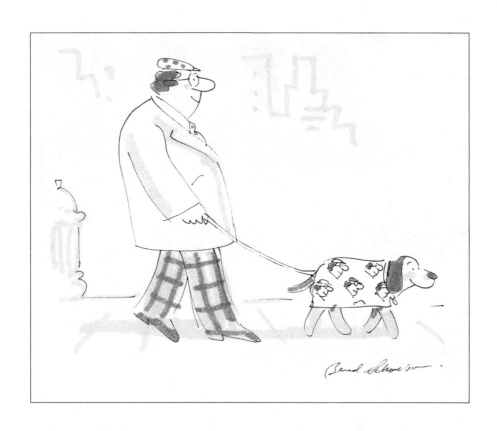

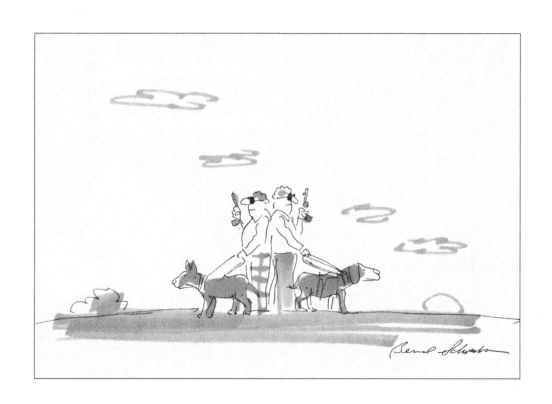

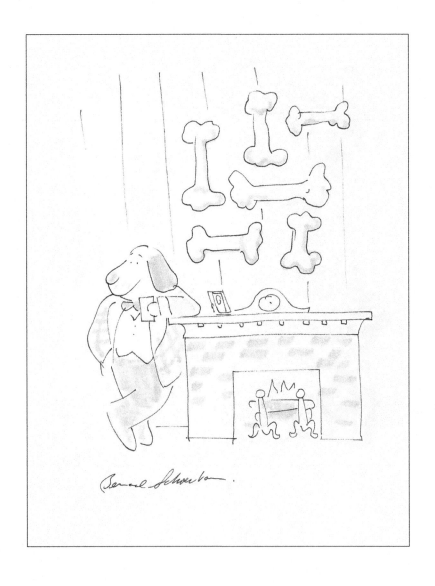

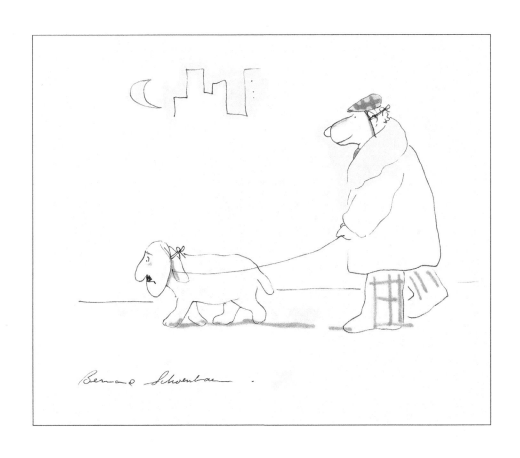

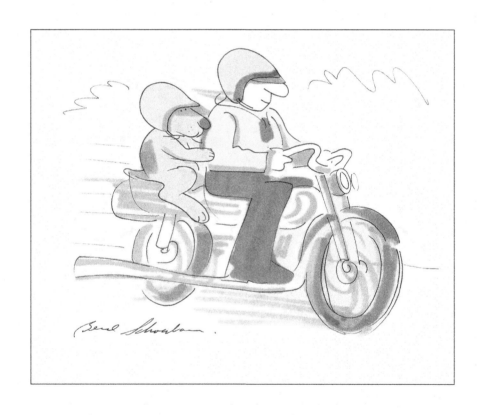

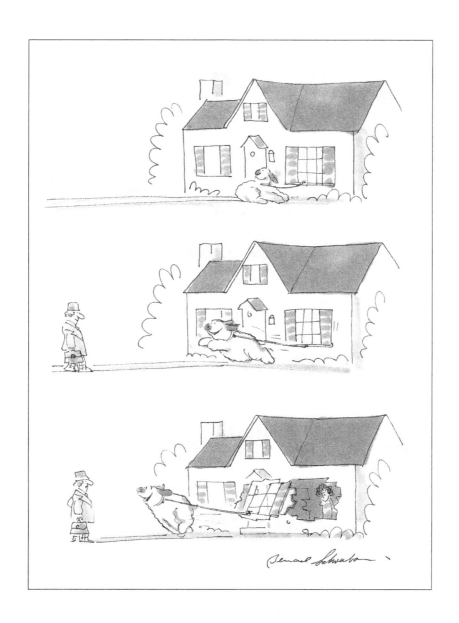

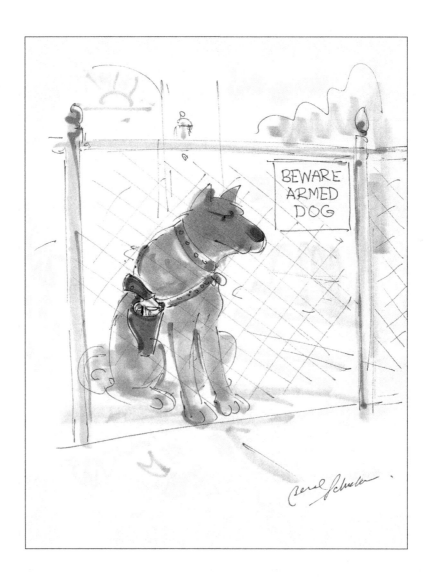

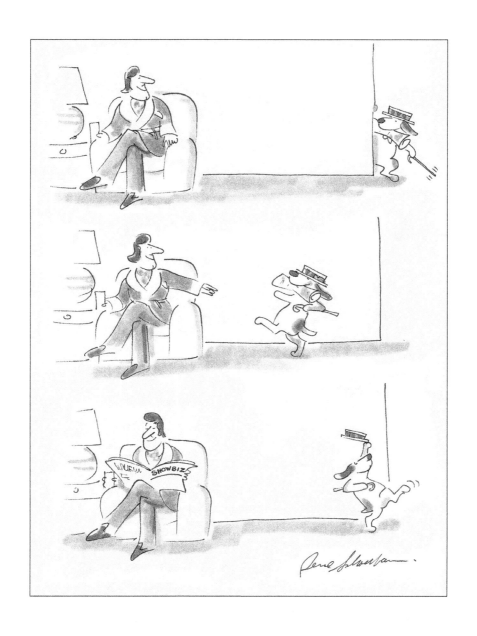

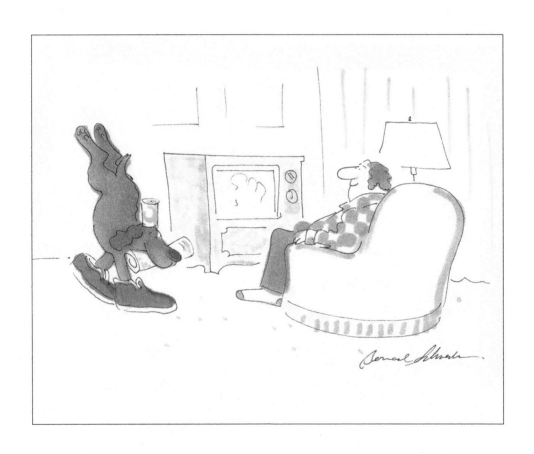

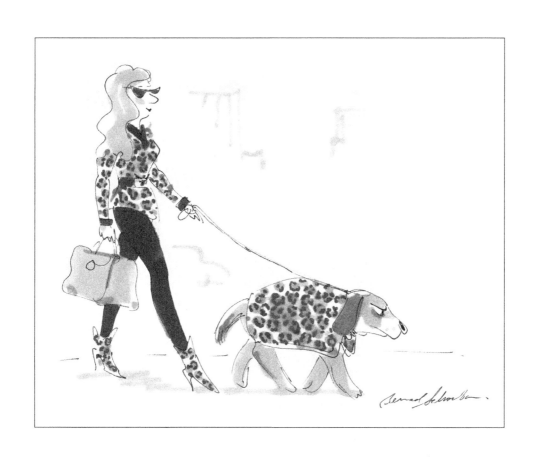

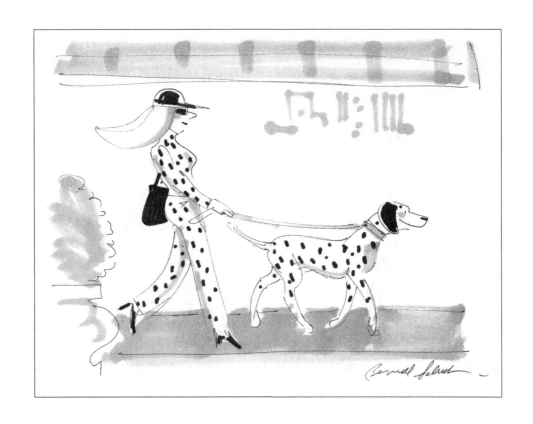

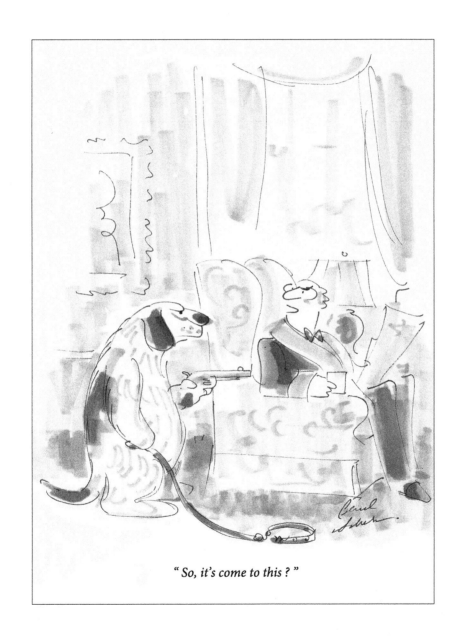

" So, it's come to this ? "

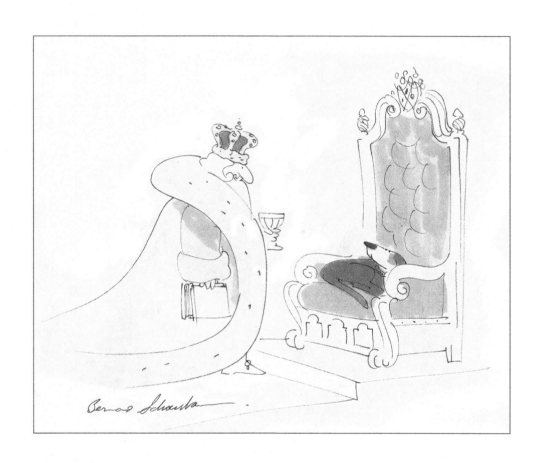

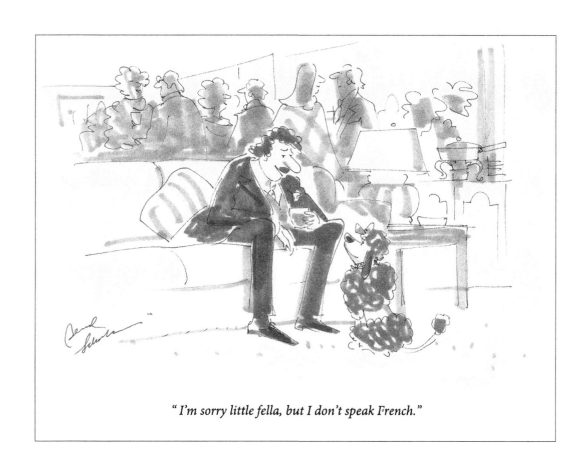

"*I'm sorry little fella, but I don't speak French.*"

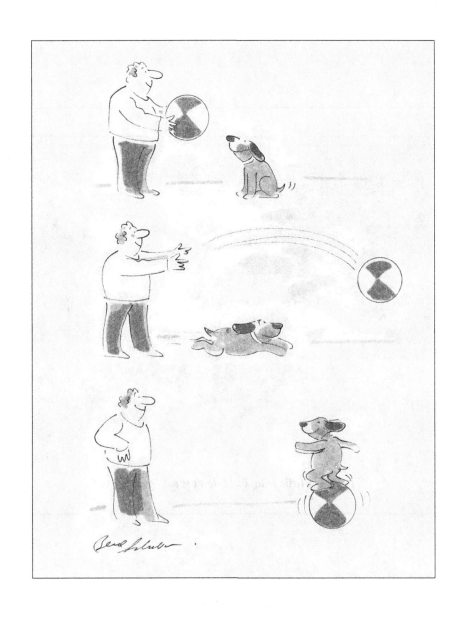

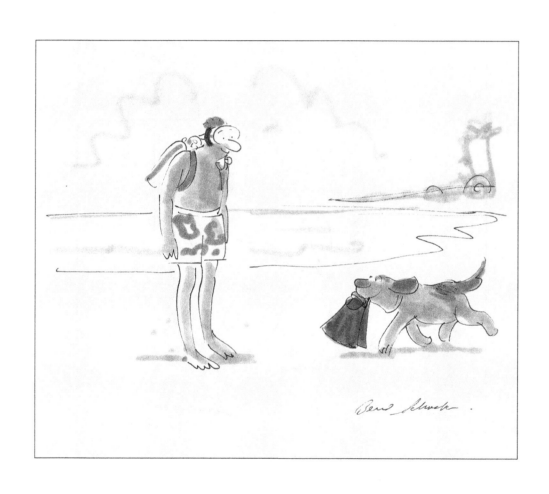

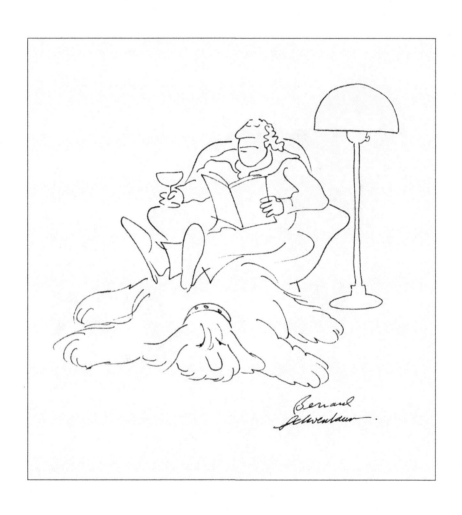

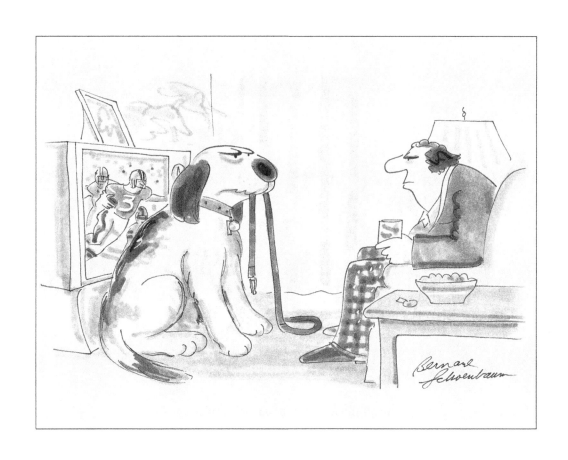

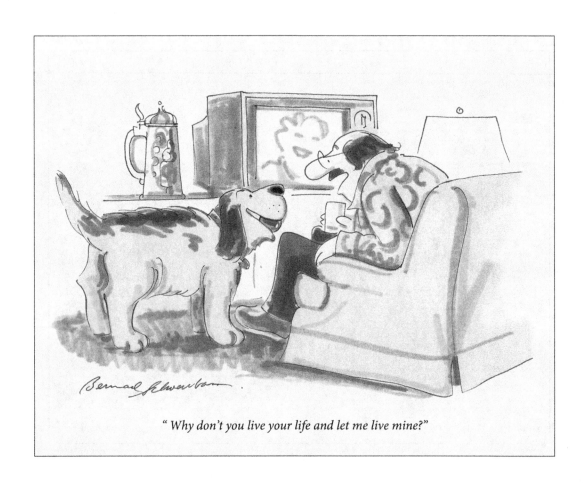

" *Why don't you live your life and let me live mine?* "

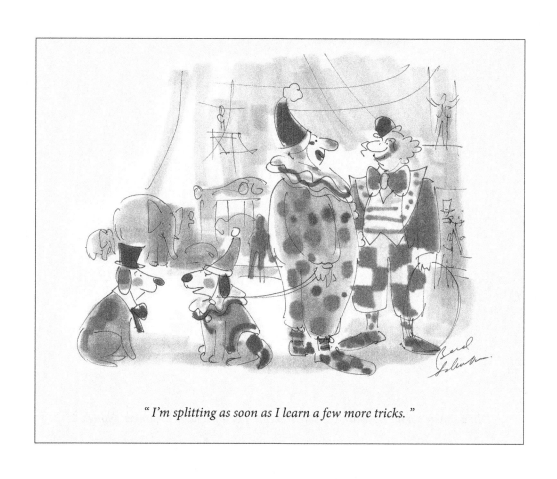

" *I'm splitting as soon as I learn a few more tricks.* "

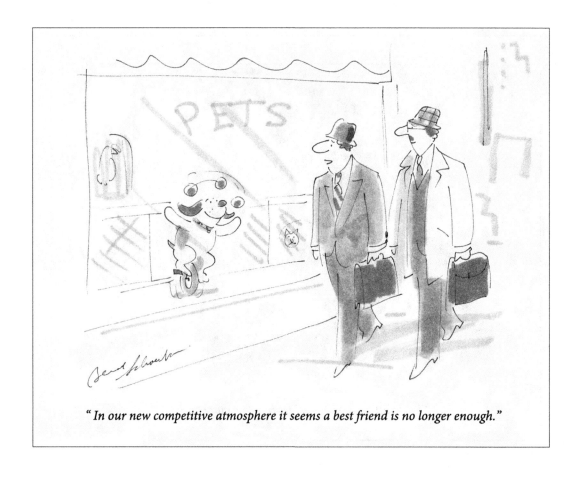

"In our new competitive atmosphere it seems a best friend is no longer enough."

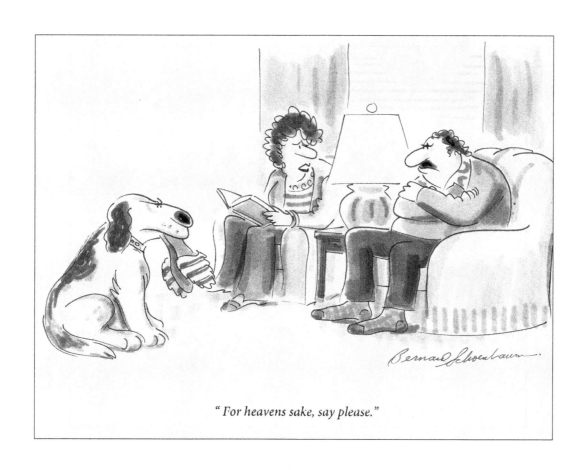

"For heavens sake, say please."

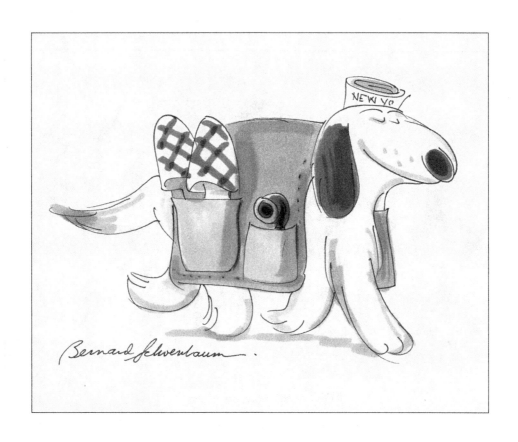

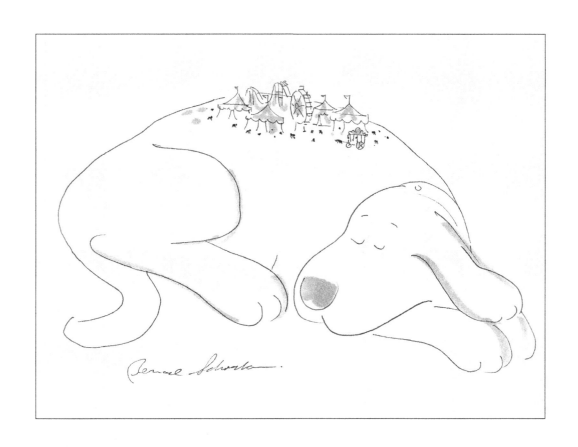

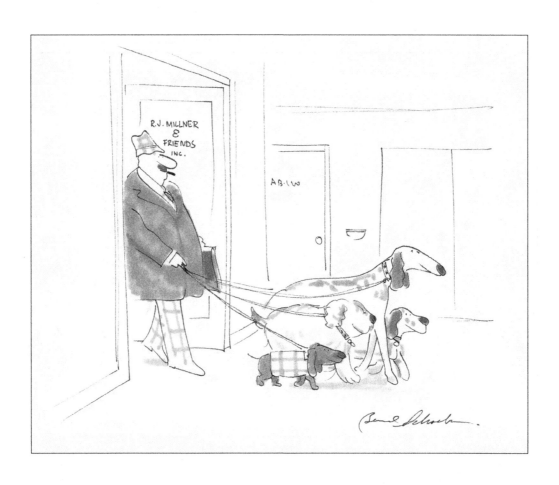

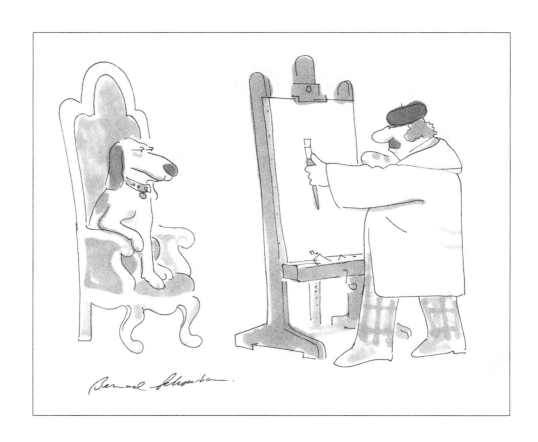

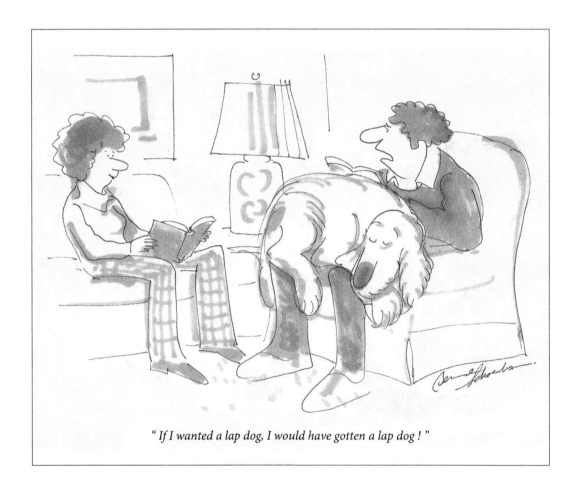

" *If I wanted a lap dog, I would have gotten a lap dog !* "

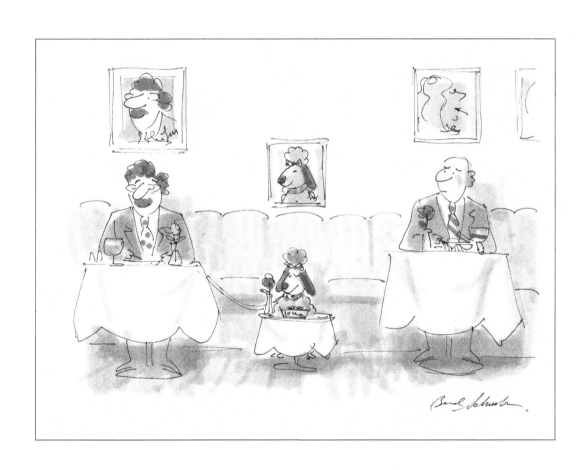

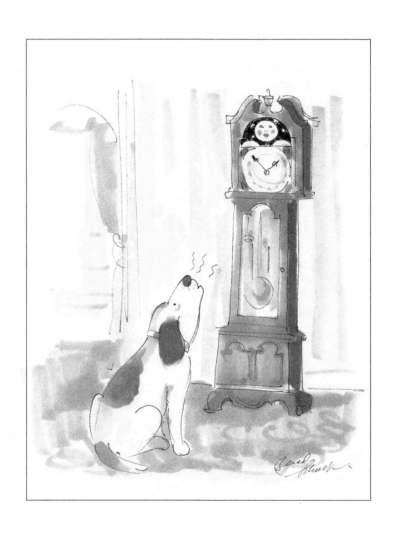

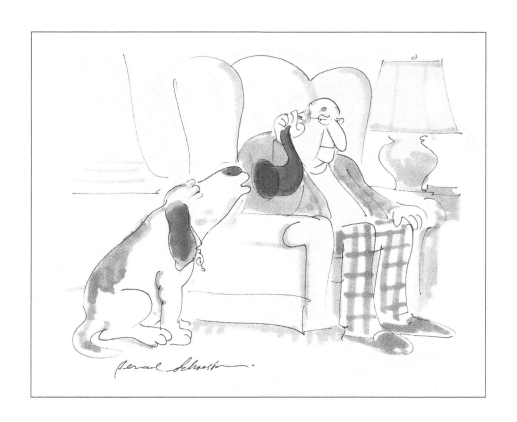

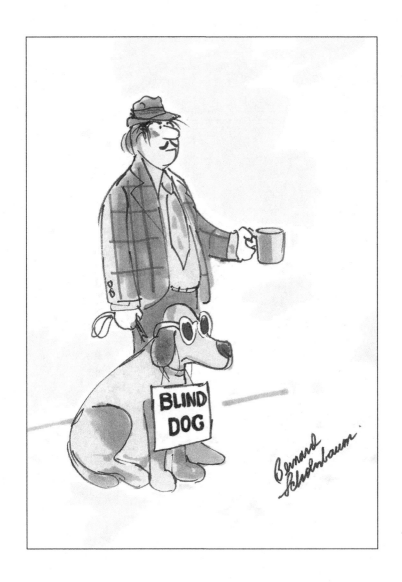

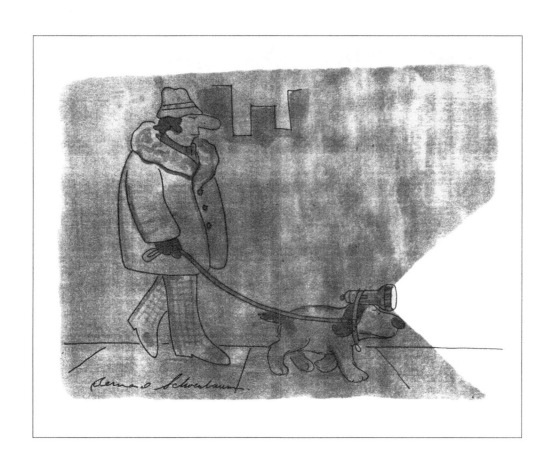

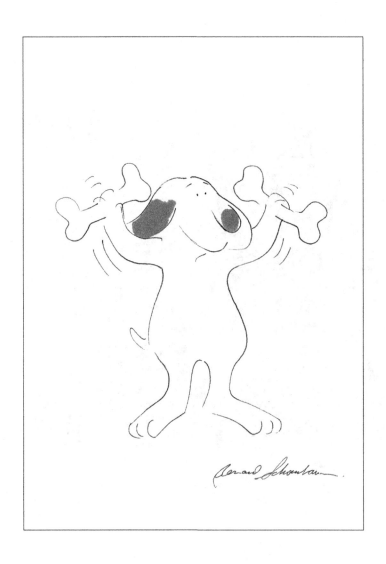

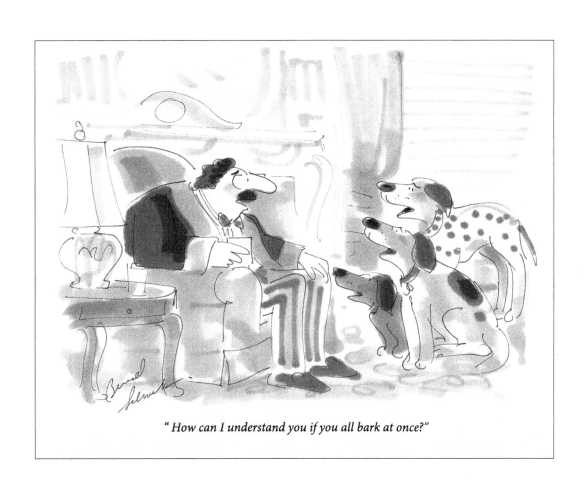

" *How can I understand you if you all bark at once?*"

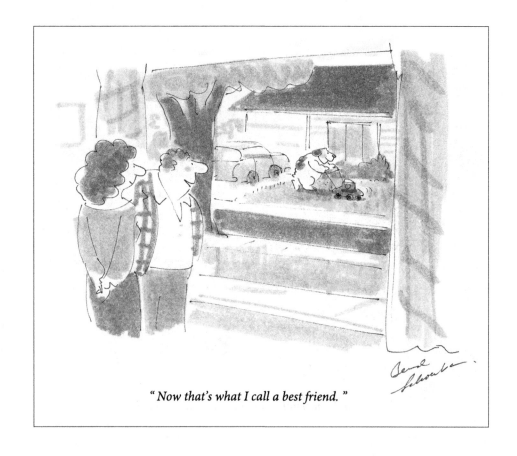

"Now that's what I call a best friend."

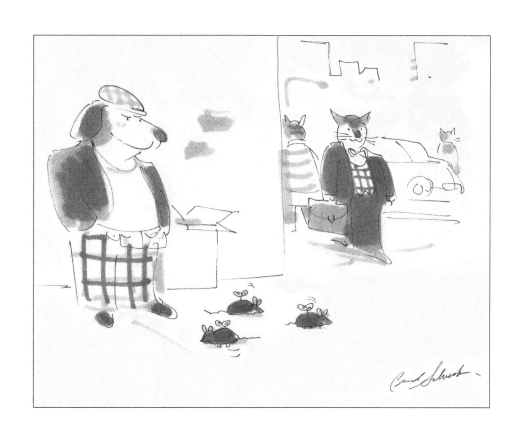

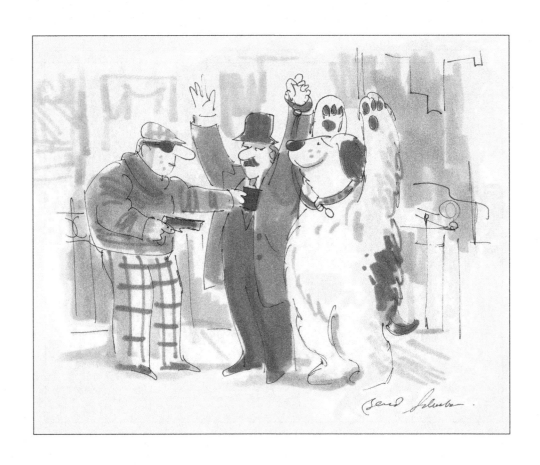

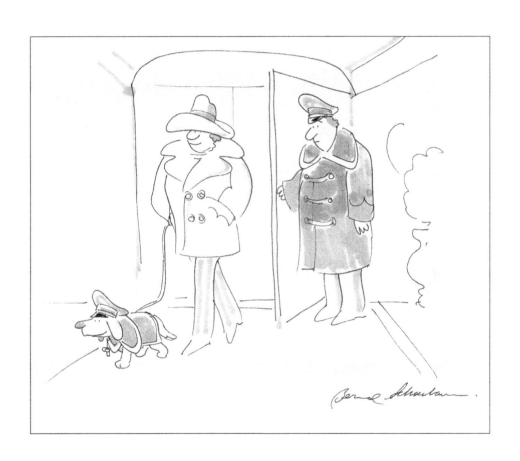

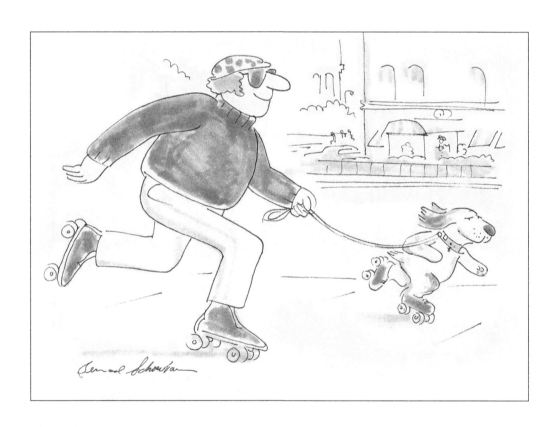

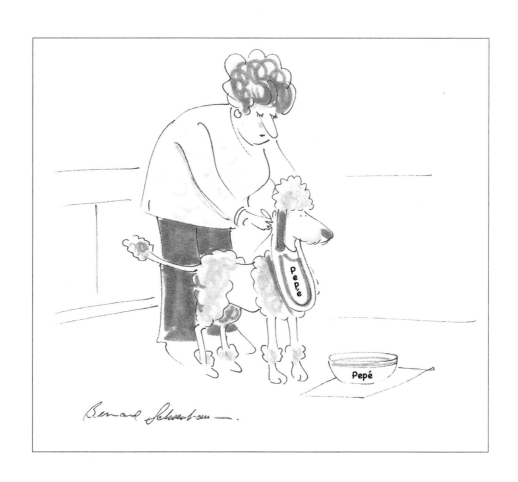

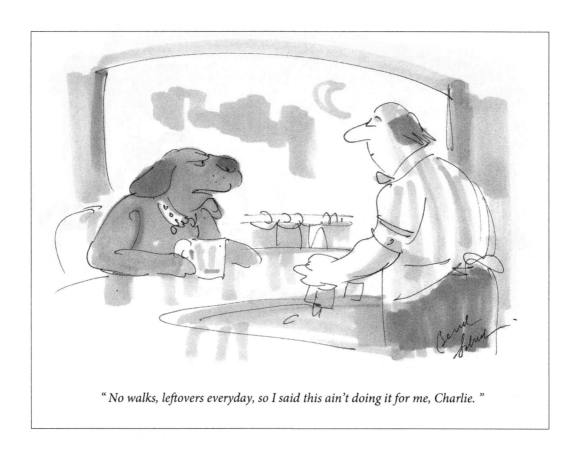

"*No walks, leftovers everyday, so I said this ain't doing it for me, Charlie.*"

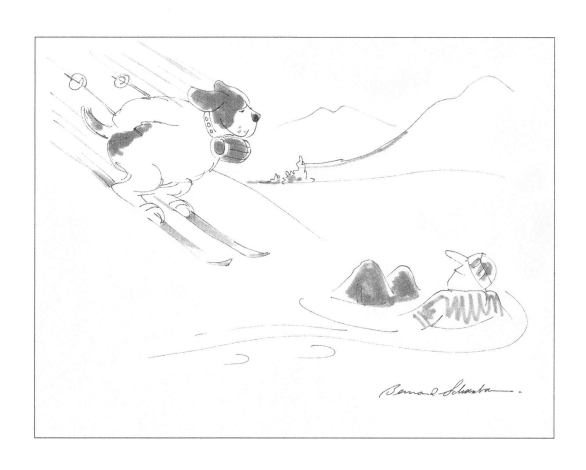

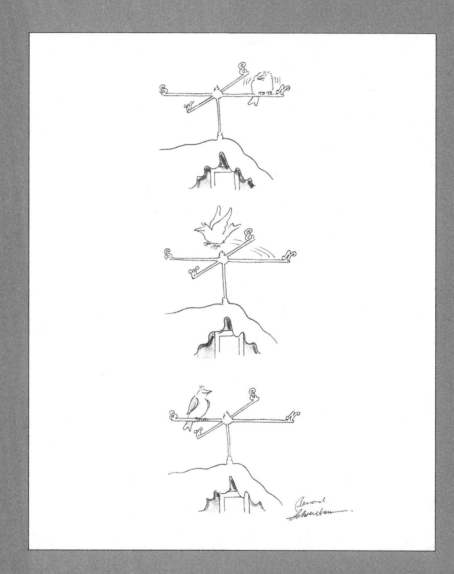

&Other Creatures

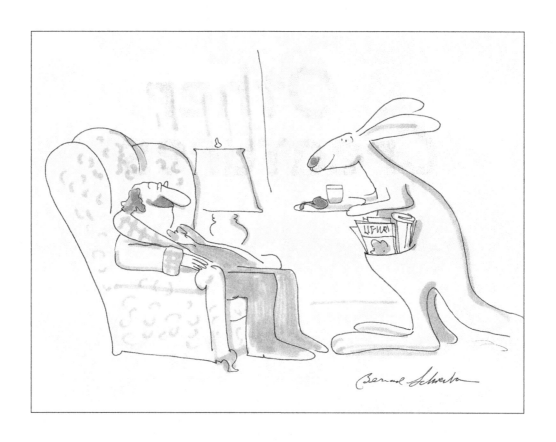

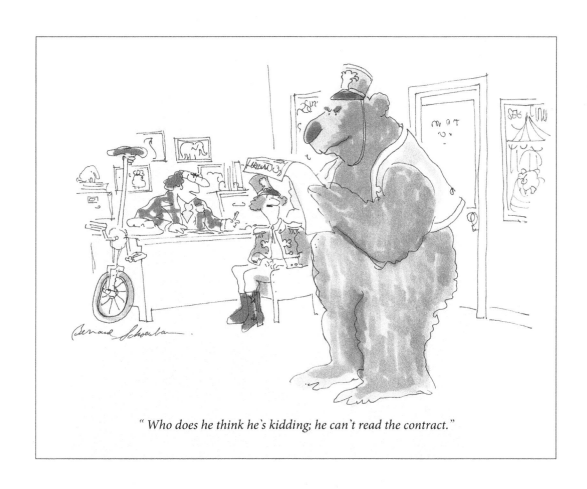

" *Who does he think he's kidding; he can't read the contract.* "

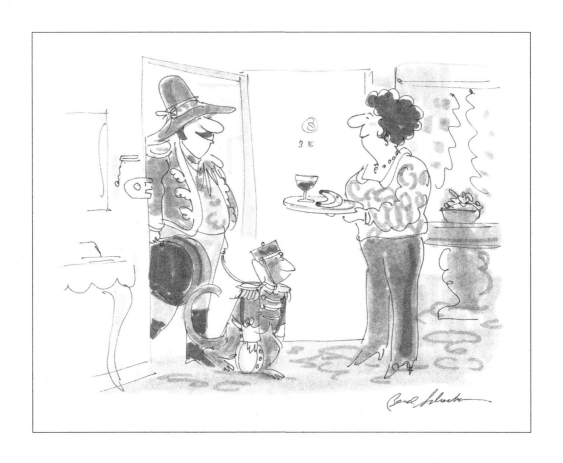

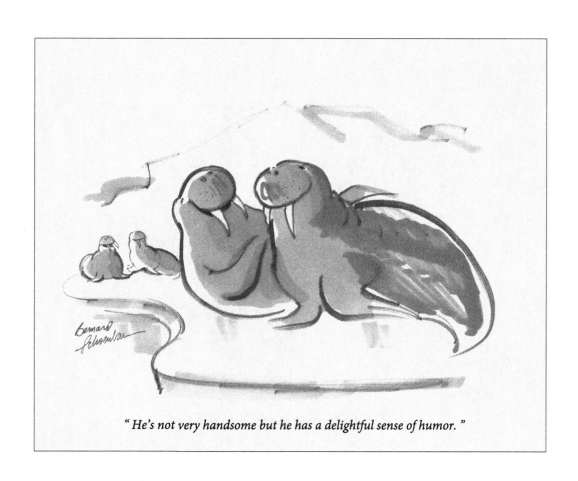

" He's not very handsome but he has a delightful sense of humor. "

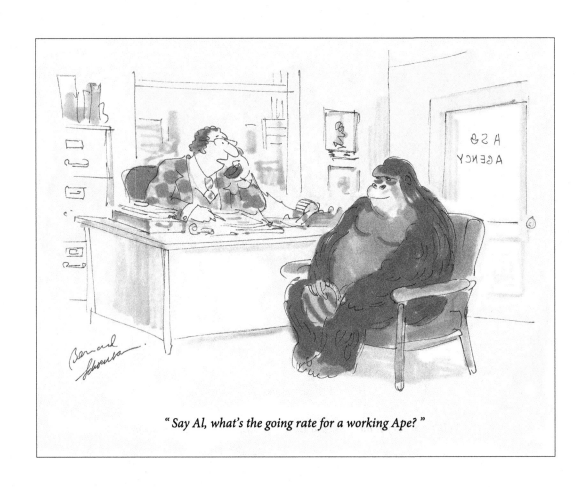

" Say Al, what's the going rate for a working Ape? "

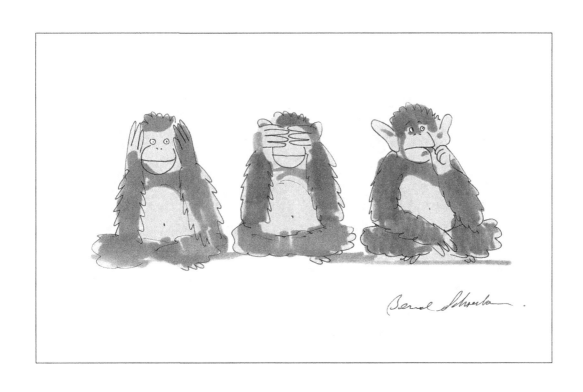

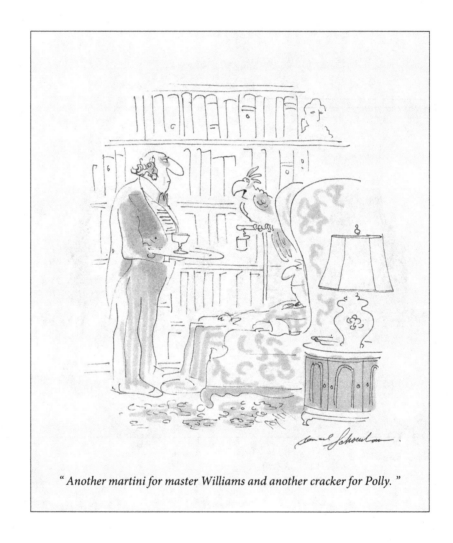

" Another martini for master Williams and another cracker for Polly. "

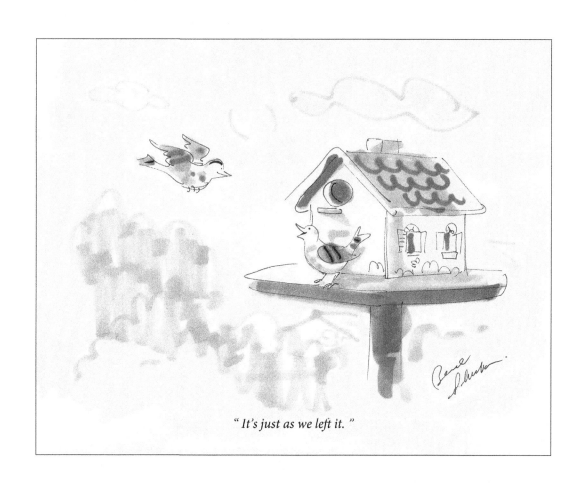

" *It's just as we left it.* "

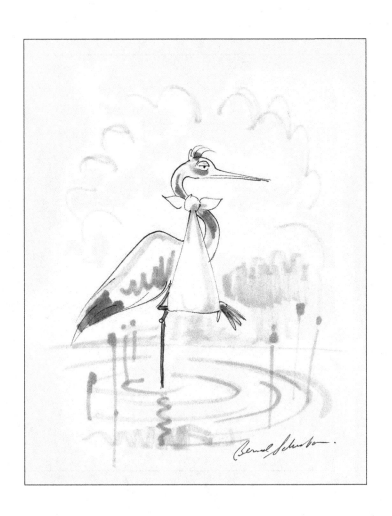

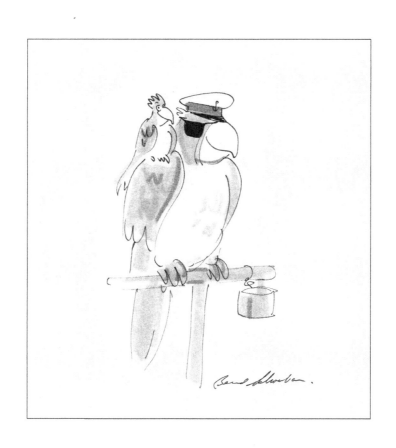

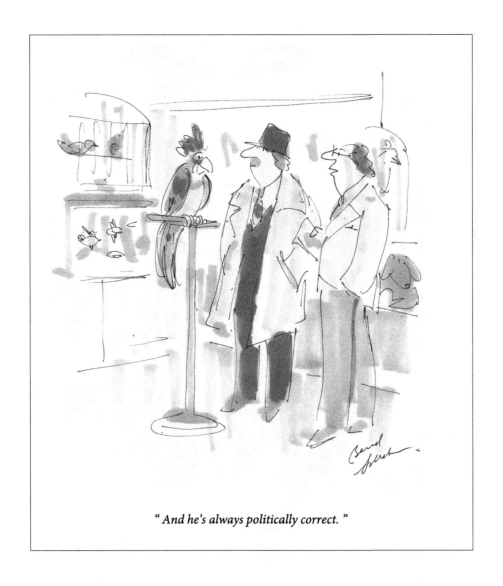

" *And he's always politically correct.* "

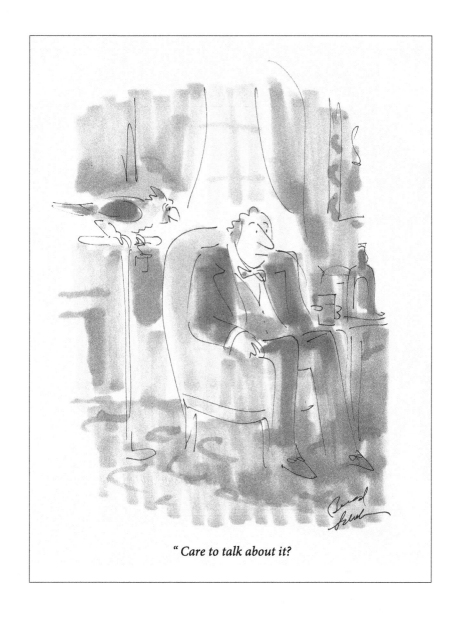

" *Care to talk about it?*

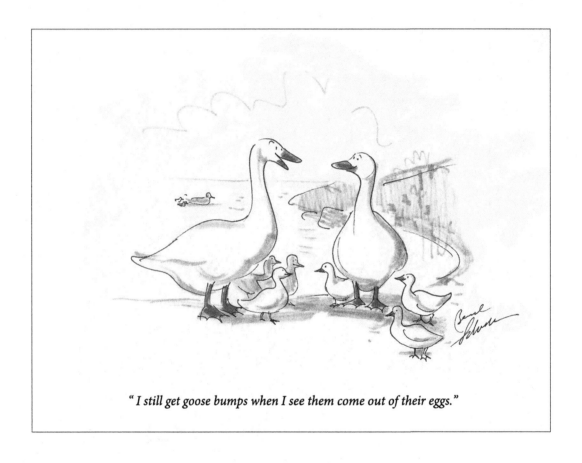

"*I still get goose bumps when I see them come out of their eggs.*"

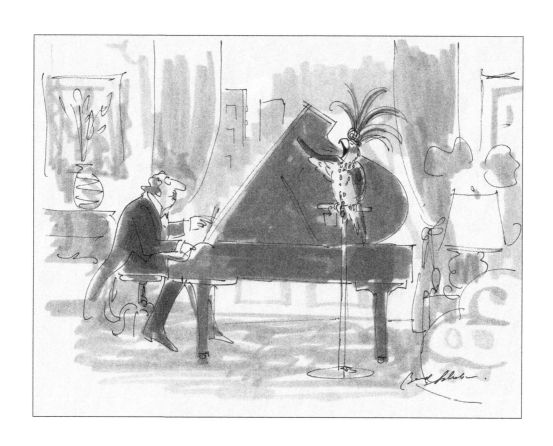

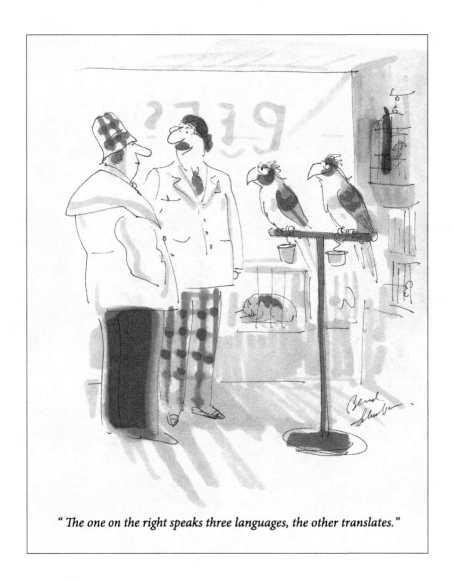

" *The one on the right speaks three languages, the other translates.* "

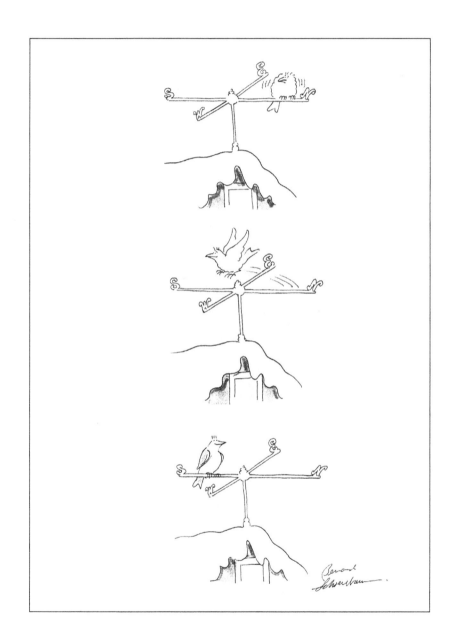

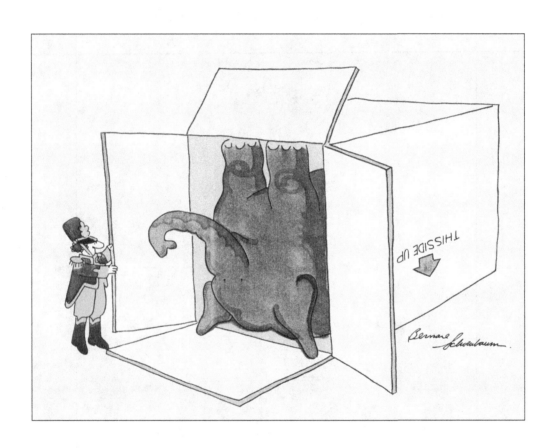

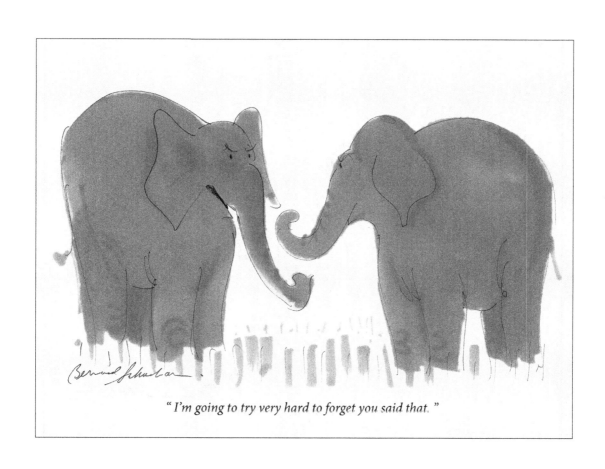

" *I'm going to try very hard to forget you said that.* "

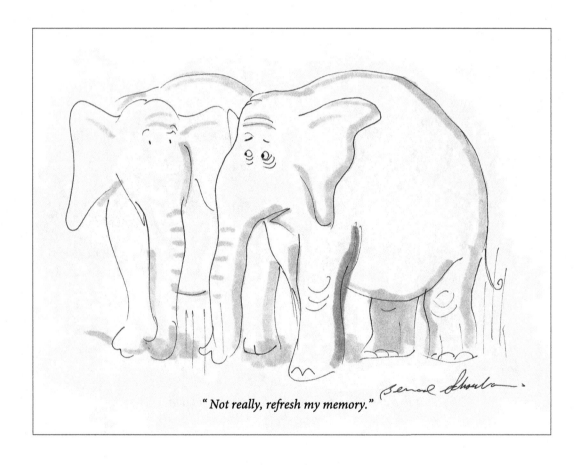

"*Not really, refresh my memory.*"

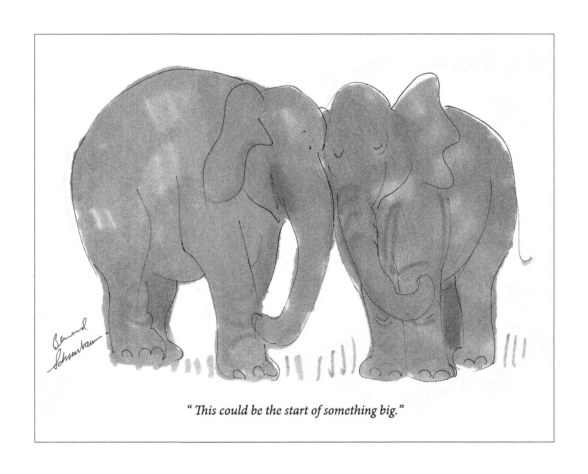

"This could be the start of something big."

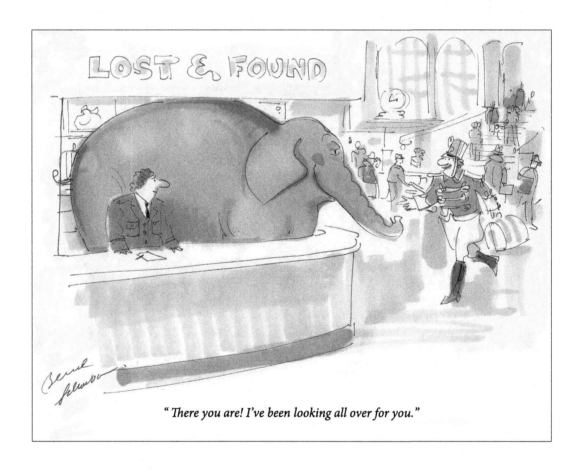

" *There you are! I've been looking all over for you.*"

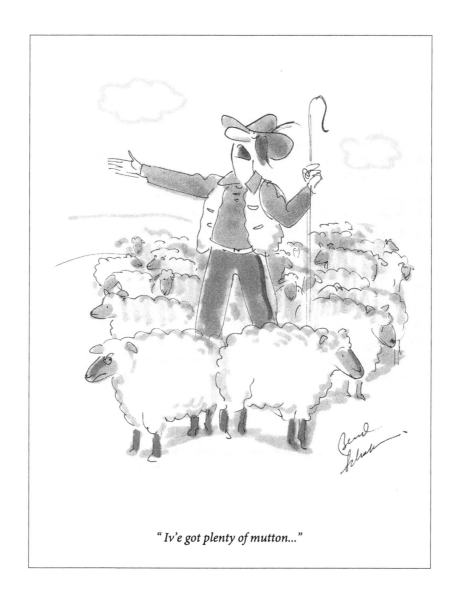

" Iv'e got plenty of mutton..."

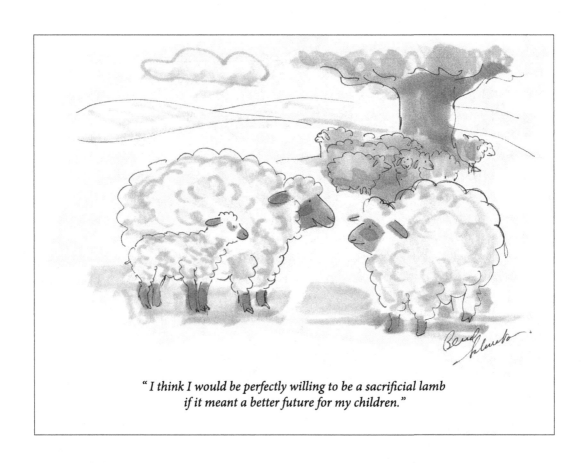

"I think I would be perfectly willing to be a sacrificial lamb
if it meant a better future for my children."

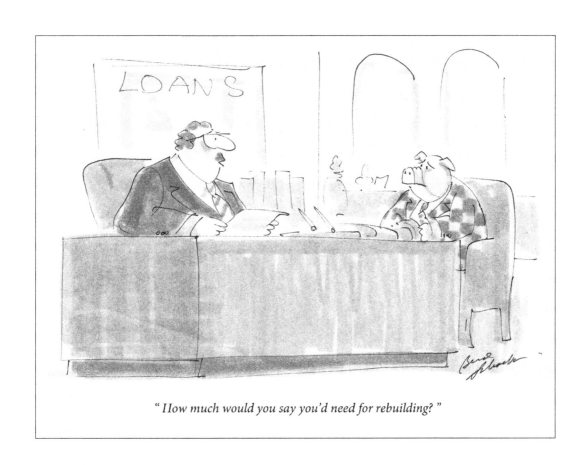

"How much would you say you'd need for rebuilding?"

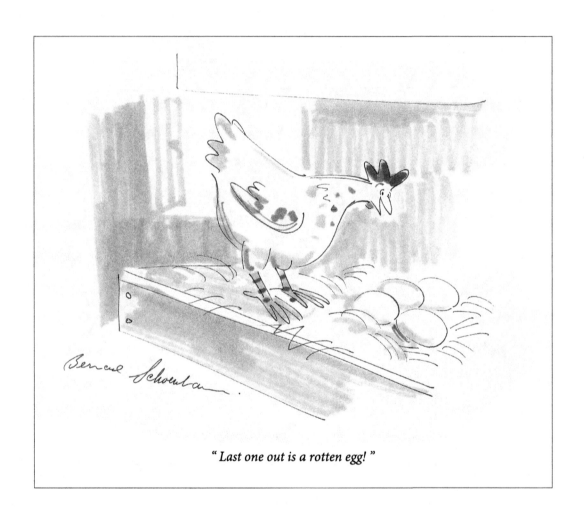

" Last one out is a rotten egg! "

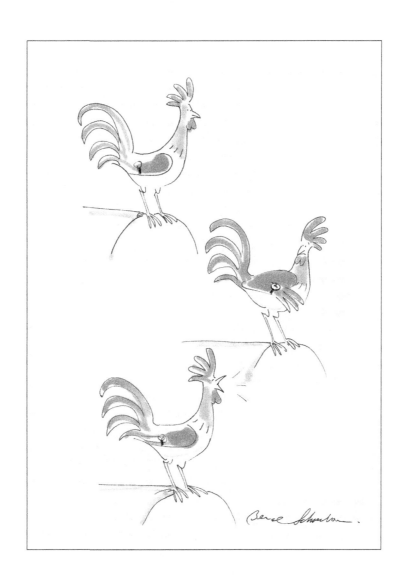

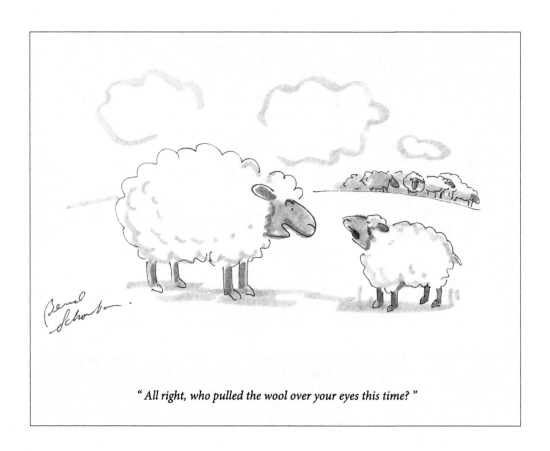

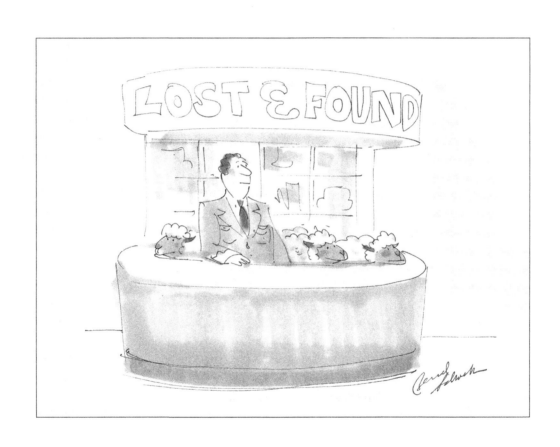

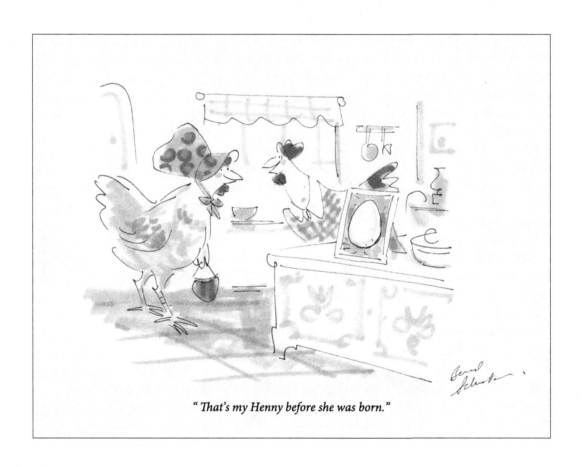

"*That's my Henny before she was born.*"

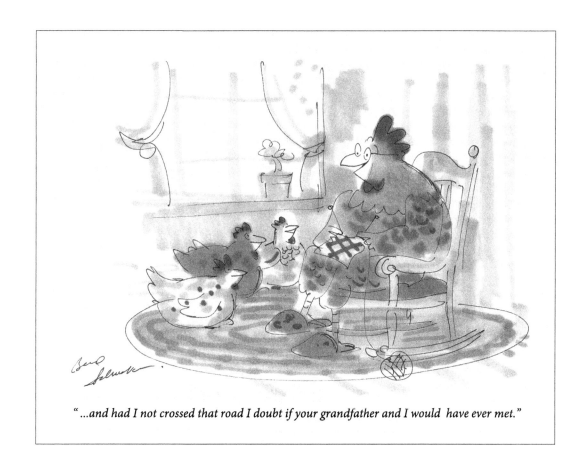

"...and had I not crossed that road I doubt if your grandfather and I would have ever met."

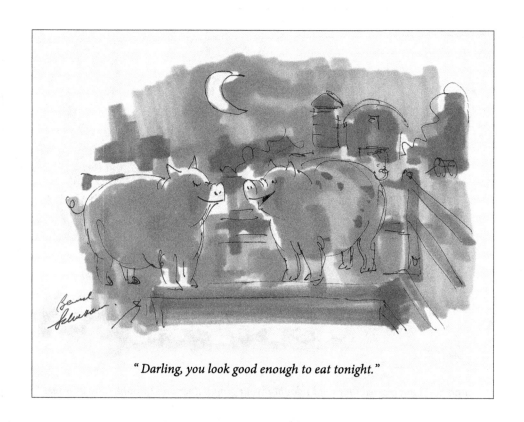

"Darling, you look good enough to eat tonight."

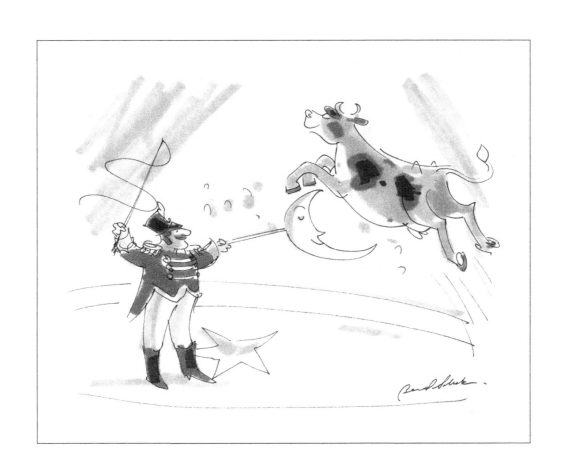

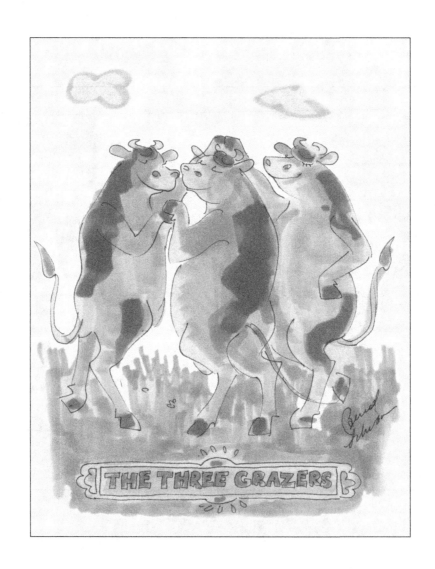

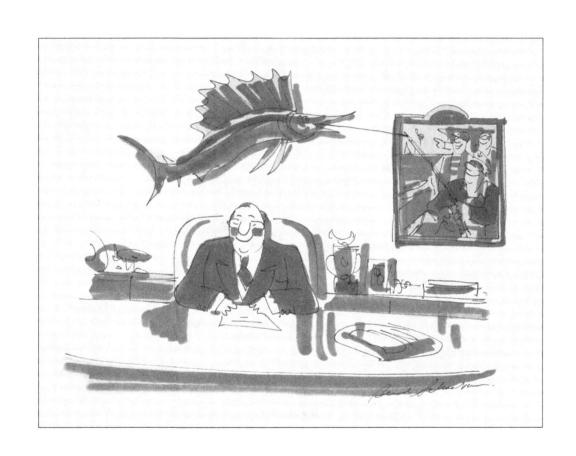

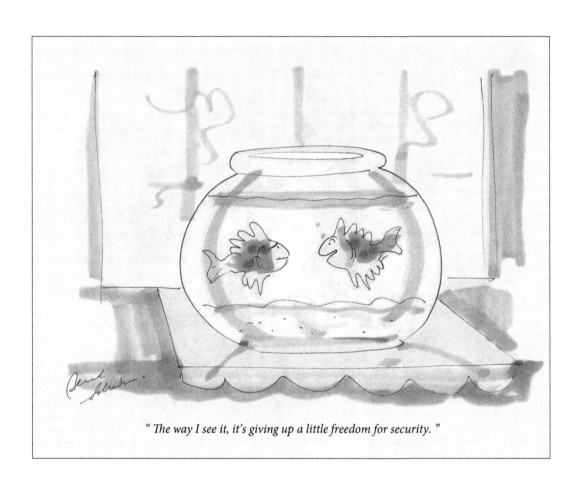

" *The way I see it, it's giving up a little freedom for security.* "

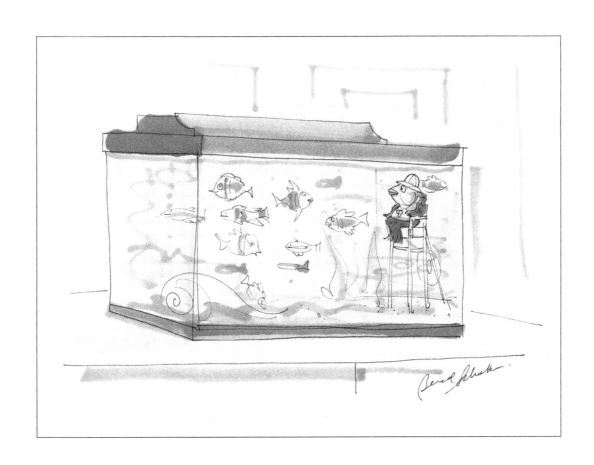

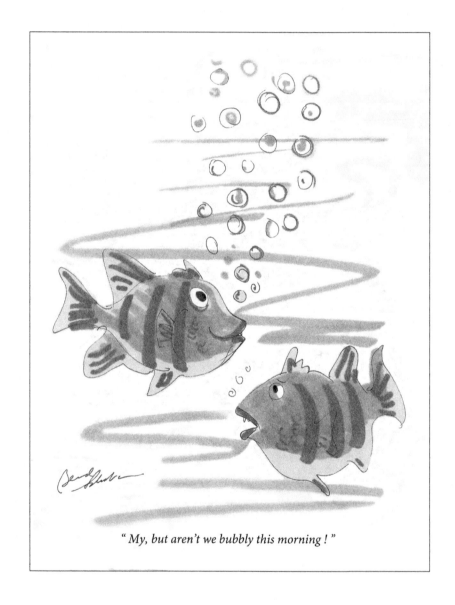

" *My, but aren't we bubbly this morning !* "

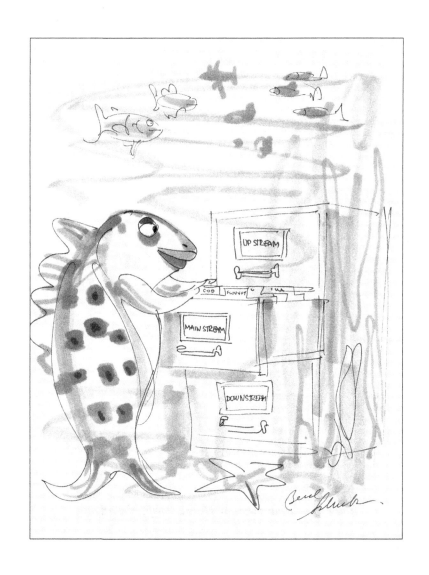

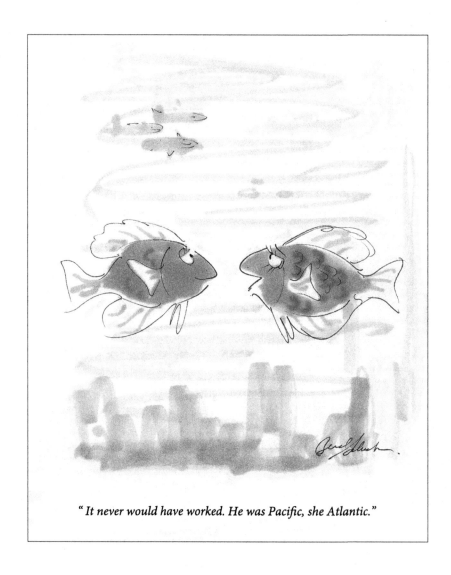

"*It never would have worked. He was Pacific, she Atlantic.*"

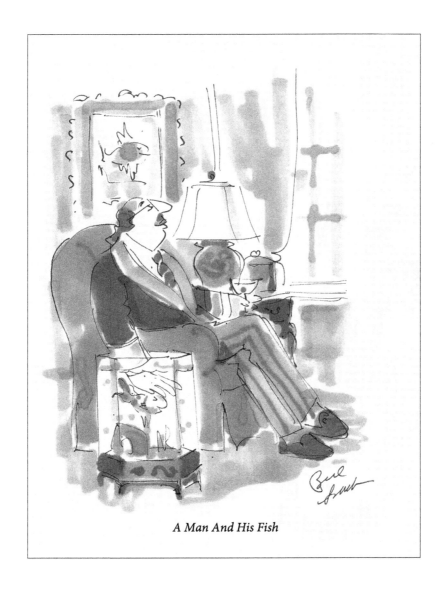

A Man And His Fish

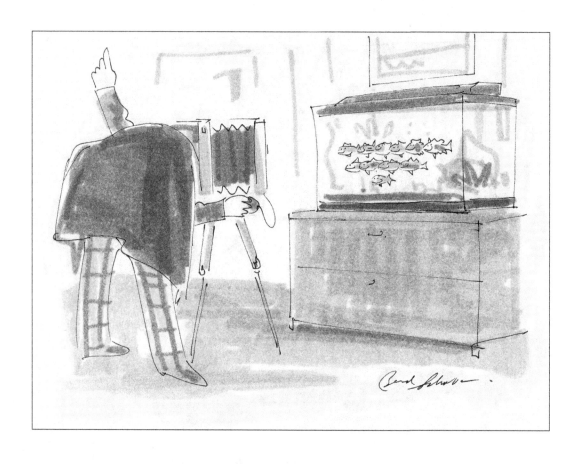

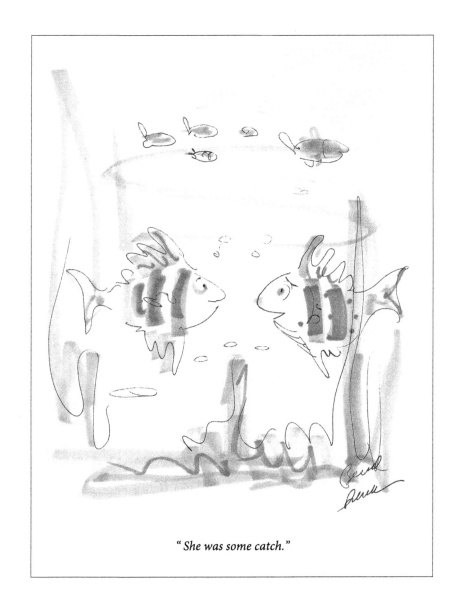

"*She was some catch.*"

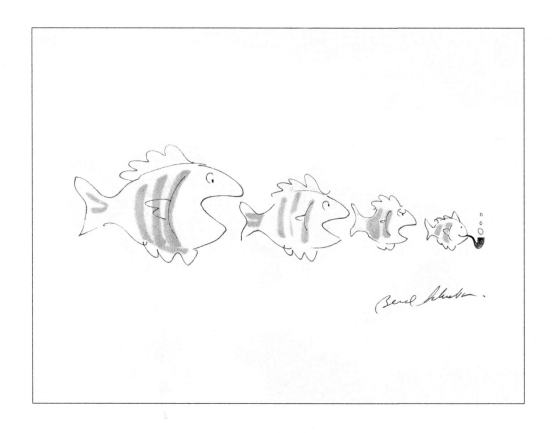

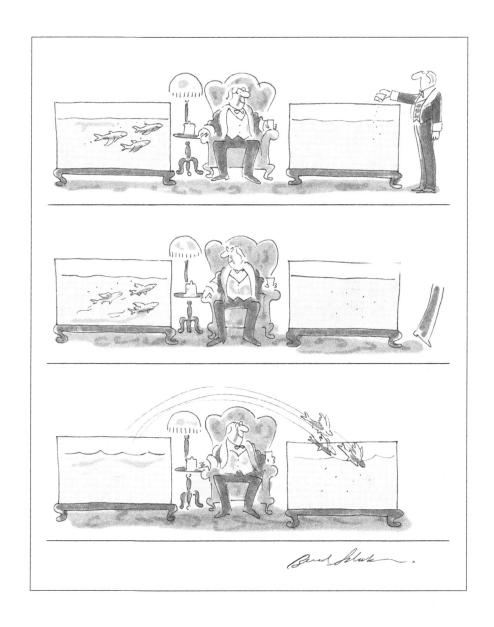

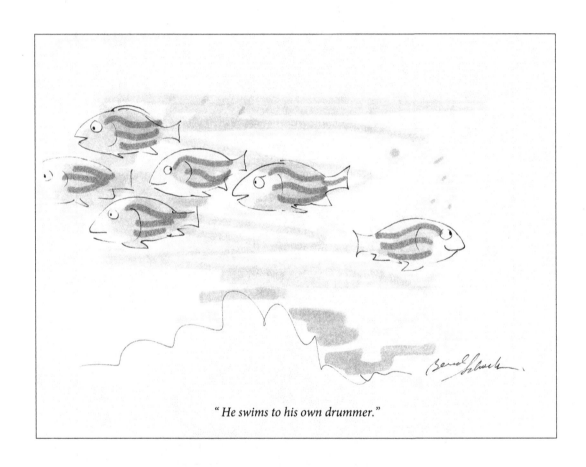

"*He swims to his own drummer.*"

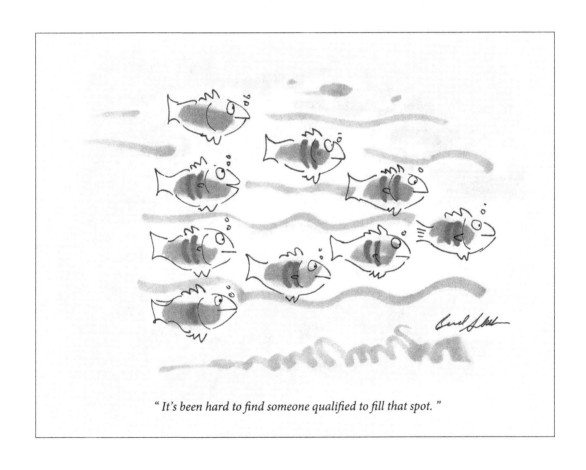

"It's been hard to find someone qualified to fill that spot."

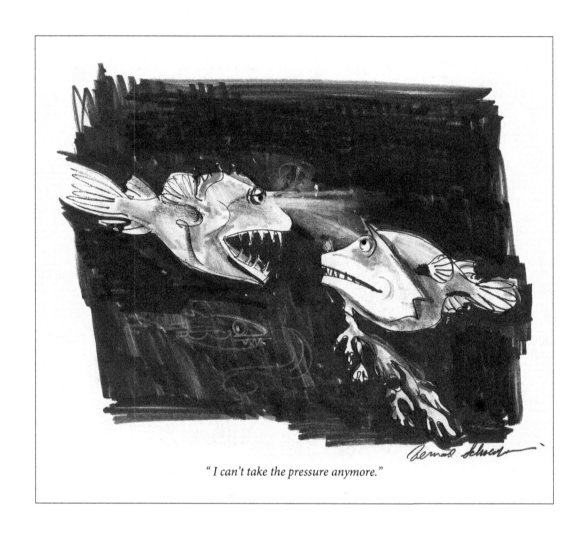

"I can't take the pressure anymore."

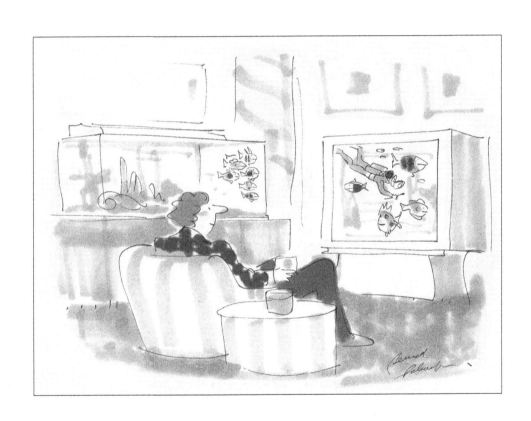

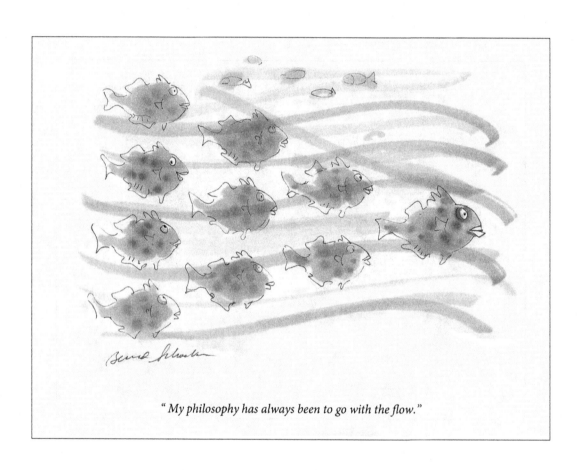

" *My philosophy has always been to go with the flow.*"

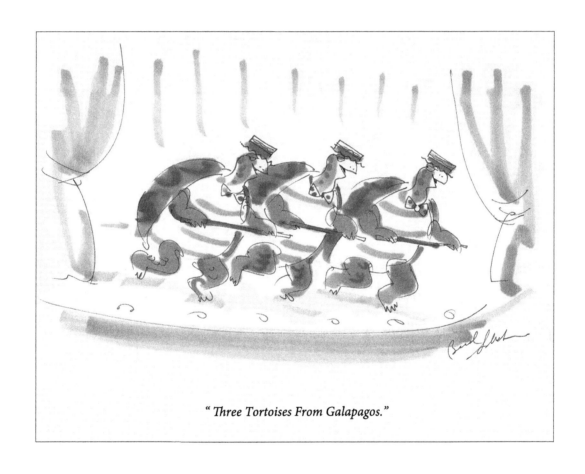

"*Three Tortoises From Galapagos.*"

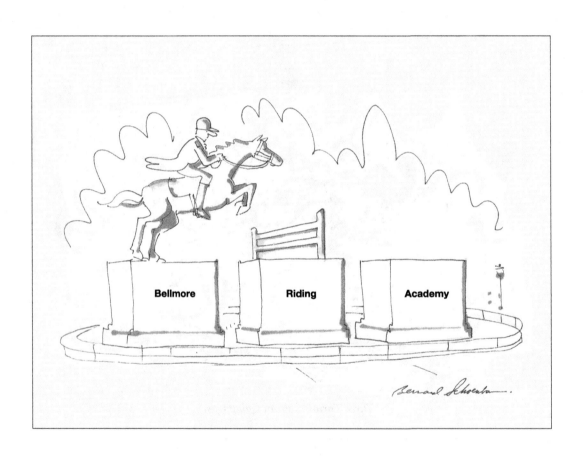

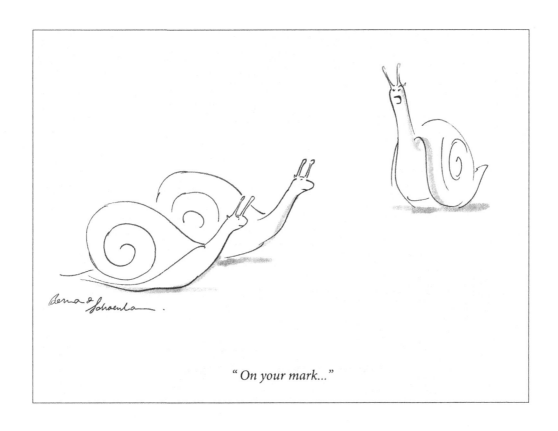

"On your mark..."

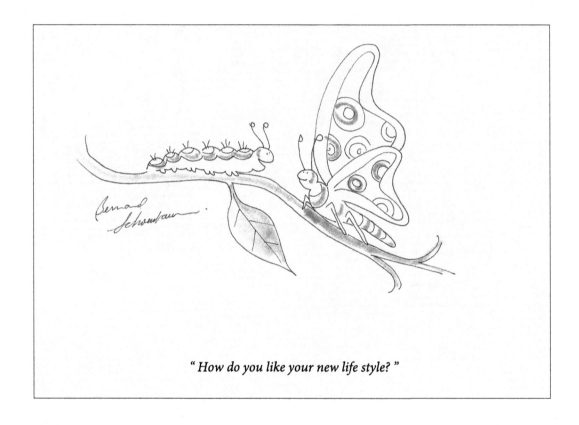

" How do you like your new life style? "

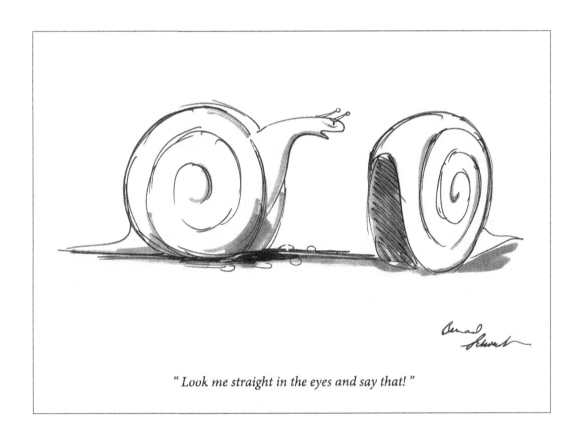

" Look me straight in the eyes and say that! "

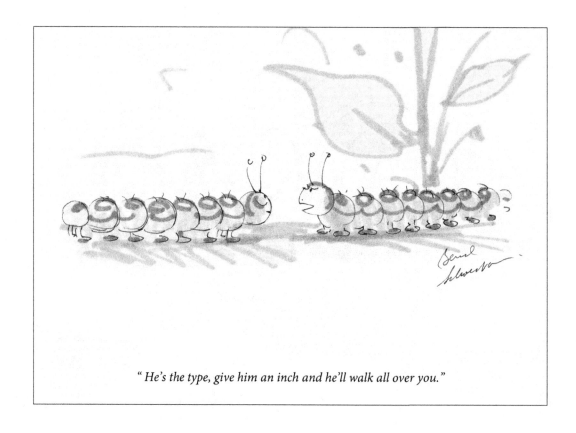

" *He's the type, give him an inch and he'll walk all over you.*"

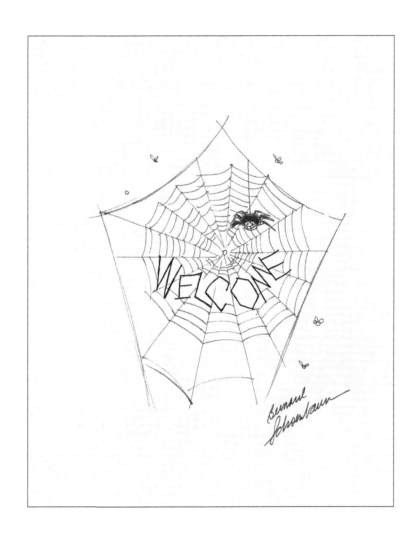

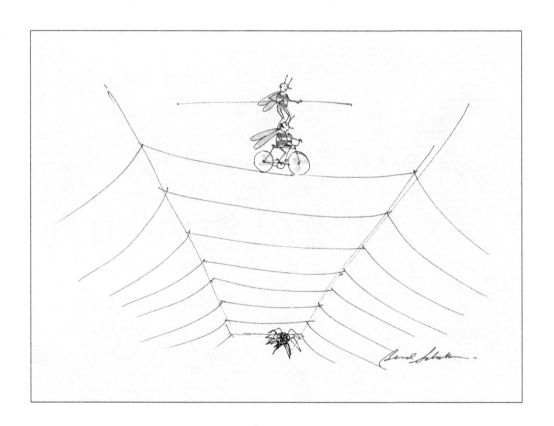

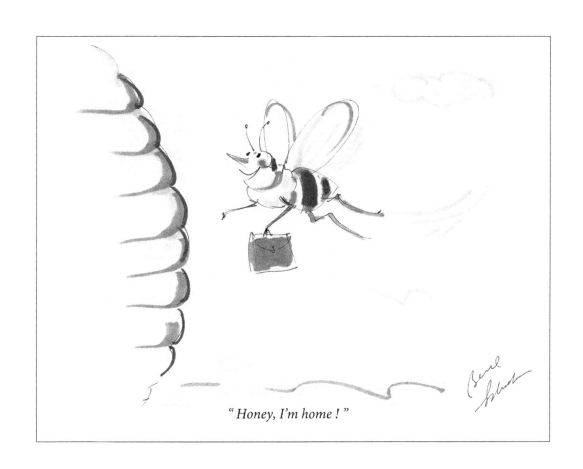

"*Honey, I'm home!*"

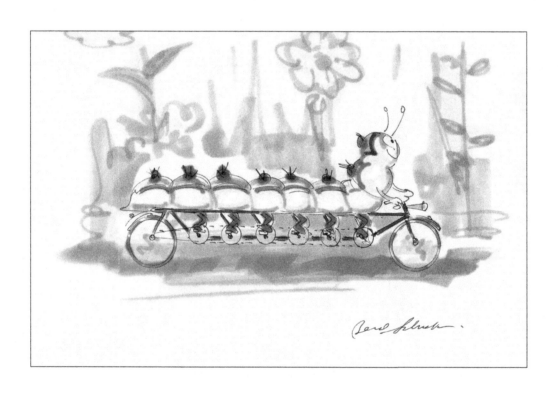

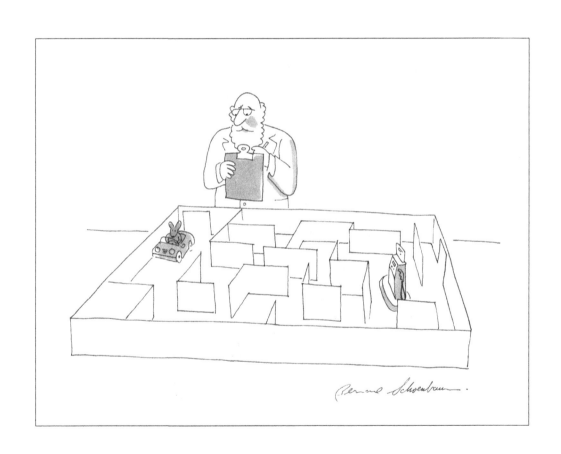

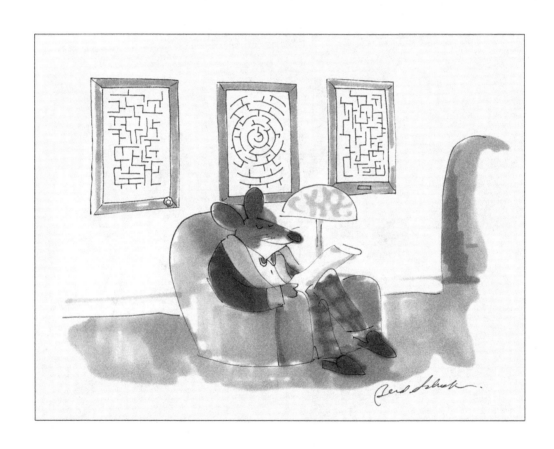

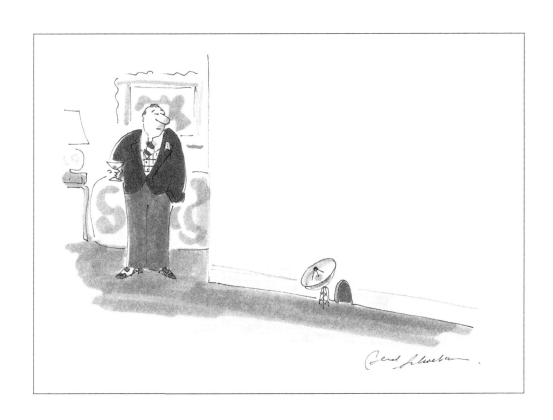

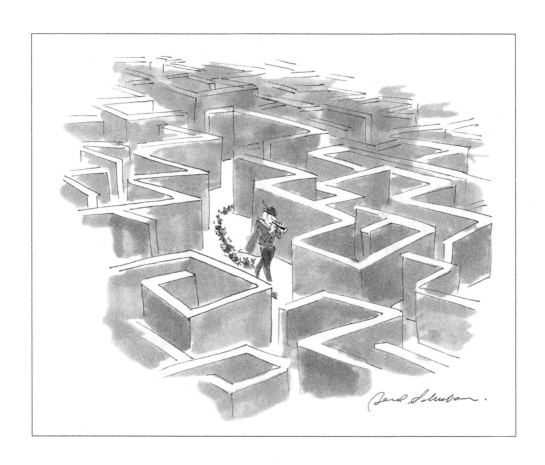

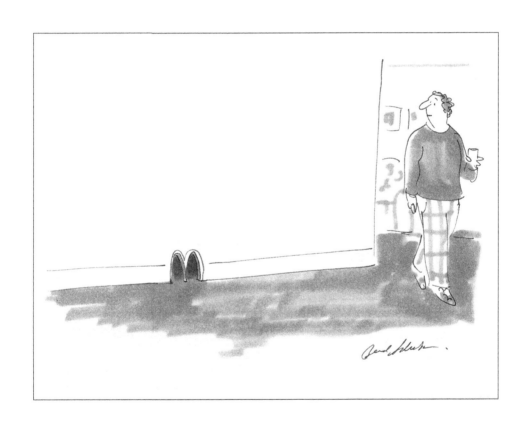

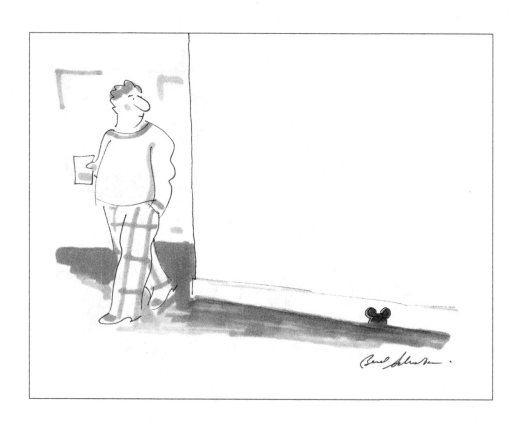

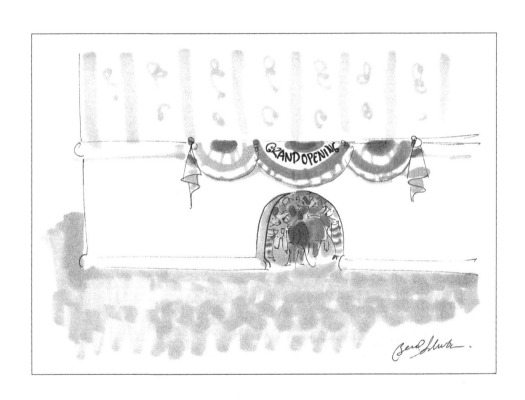

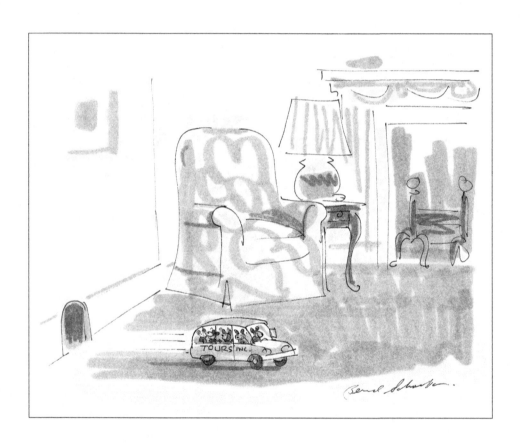

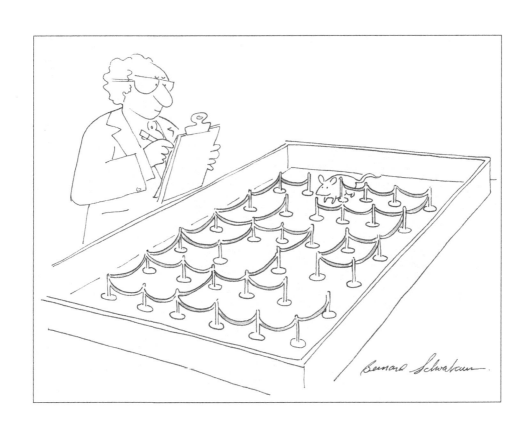

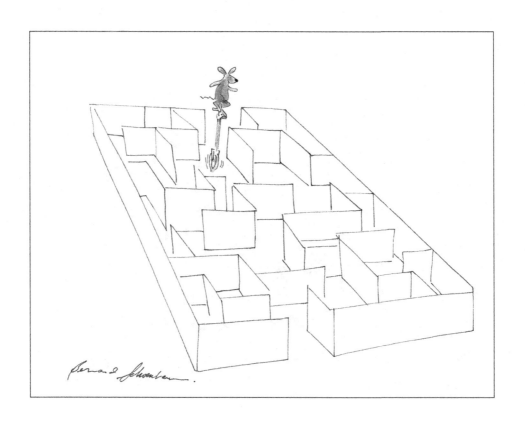

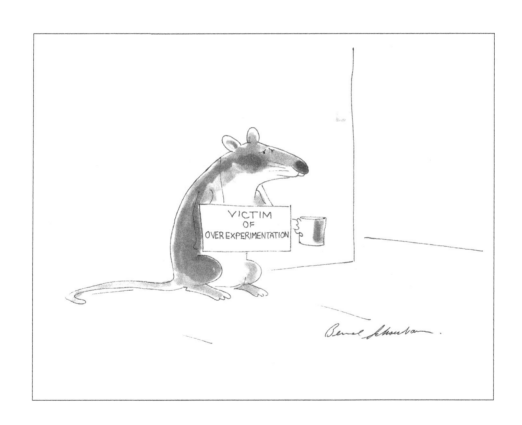

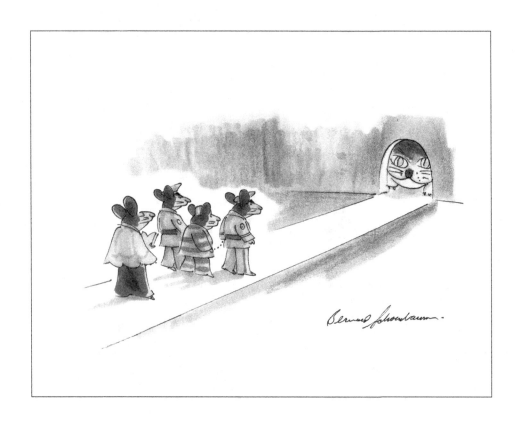

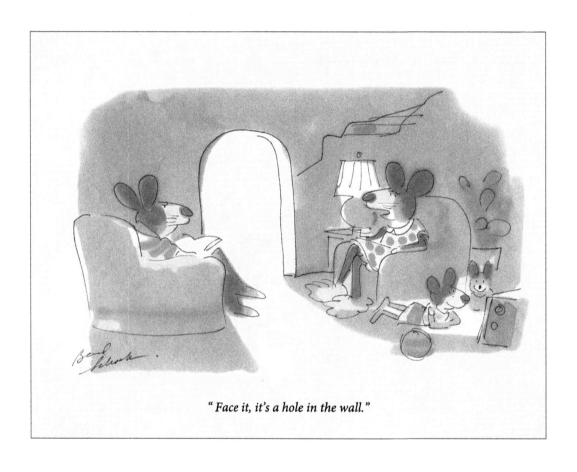

"Face it, it's a hole in the wall."

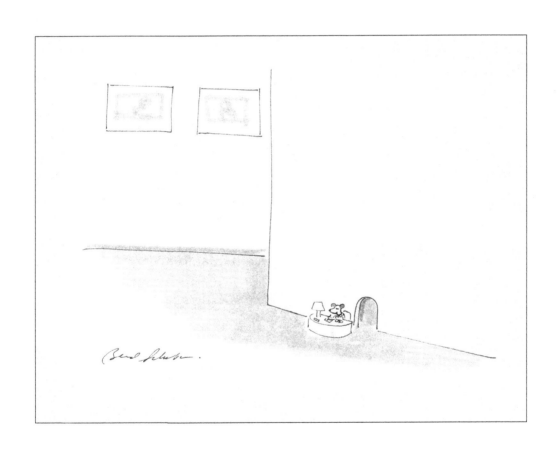

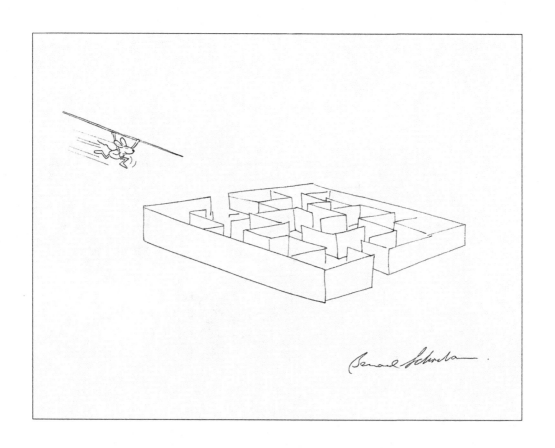

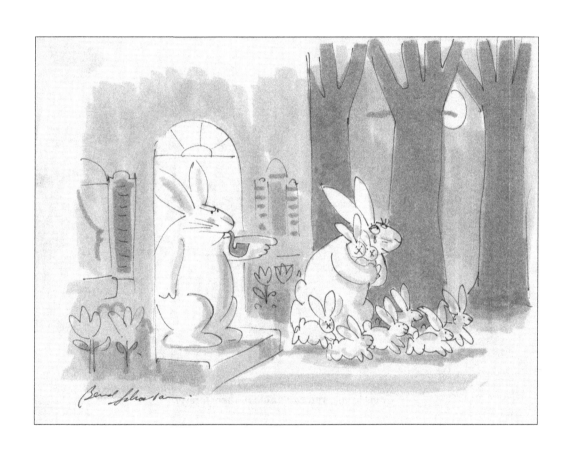

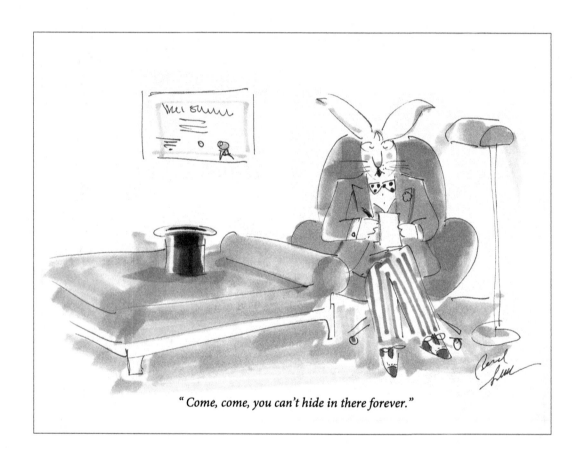

" *Come, come, you can't hide in there forever.* "

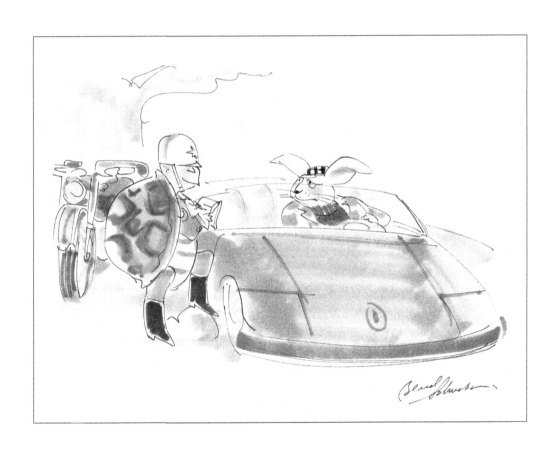

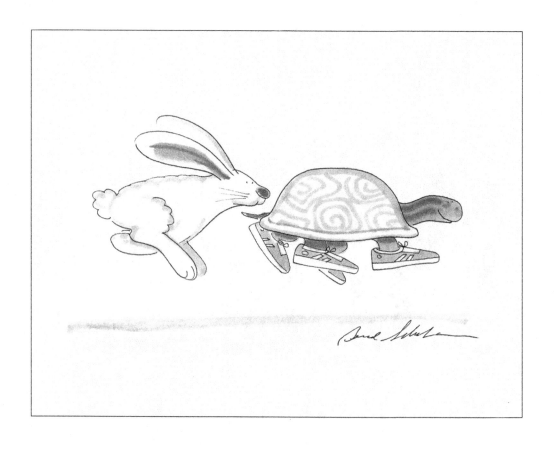

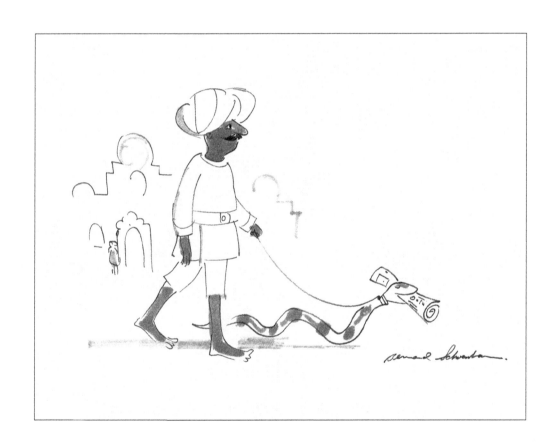

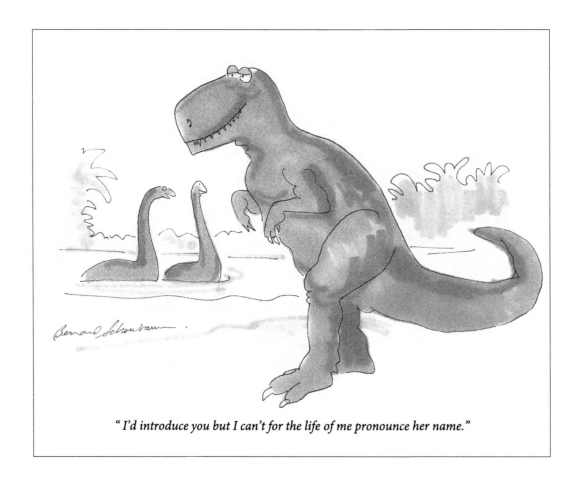

"*I'd introduce you but I can't for the life of me pronounce her name.*"

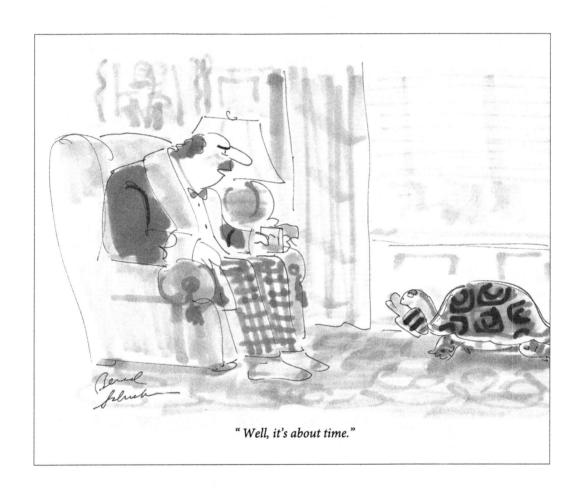

" *Well, it's about time.* "

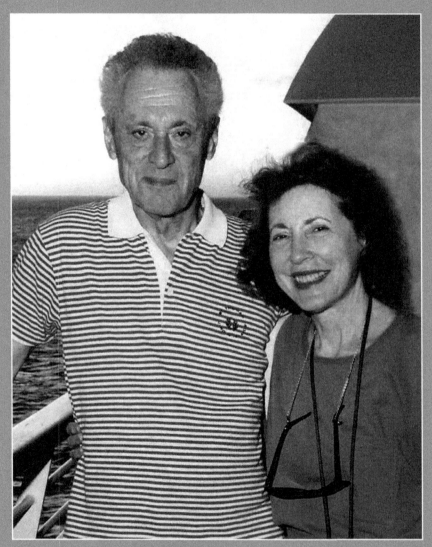

Photo of Bernard and Rhoda Schoenbaum on cruise 1994

Addendum

Bernard Schoenbaum

Bernard Schoenbaum was born and raised in New York City.
After receiving his art education at Parsons School of Design, he was a free-lance advertising illustrator for many years.

Appearing in The New Yorker since 1974, he became a contract cartoonist with more than 400 cartoons published. His cartoons have been reprinted in books and periodicals worldwide and are also in many private collections.

His other endeavors included teaching the figure, life drawing, portrait sketching, sculpture, oil painting and water colors. These have also been privately collected.

He and his wife, Rhoda, a retired librarian, resided in Whitestone, New York with a winter residence in West Palm Beach, Florida.

His three grown daughters are Laura Schoenbaum Rothenberg of Shirley, New York, a graphic designer, Audrey Tufano of East Meadow, New York, a computer technician and Joyce Dara of Santa Monica, California, Principal, El Sereno Middle School and Magnet Center - An International Baccalaureate World School and Granddaughter Cassandra Tufano is a graduate of SUNY Albany.

Bernard Schoenbaum
Memoir by Rhoda A.Schoenbaum

Artist, loving husband, father, grandfather.

His hands were clenched at the end leading me to think he was fighting,
yes, fighting the force that overpowered him.

During life he fought with trained pen, full heart and strong talent.
His sculpture, oil paintings, water colors and numerous portrait sketches
created for people throughout the world are a momentous legacy.

But the cartoons - over four hundred published in The New Yorker
Magazine (where he was a contracted cartoonist) as well as hundreds in
other periodicals and in countless books were his especial pride.

There is a Native American Proverb:"We will be known forever by the
tracks we leave." Bernard Schoenbaum left indelible, joyous art tracks.
Bernard was a true Artist and ethical human being with a sharp wit.
He was a husband, father and grandfather without peer.

A Letter written by
Alex Noel Watson

(Reproduced with author's permission)

ALEX NOEL WATSON · June 2 · 2010 ·

Noel Watson

Dear Rhoda,

Naturally, I was deeply sorry and grieved to receive the news of Bernie's passing. Many thanks for sending me the card with the information; very much appreciated. The next day I received from Henry Martin the obituary from *The New York Times*. My heartfelt sympathy to you all.

I always regarded Bernie as one of my very special New York friends and colleagues. New York was such a prominent and important period in my life, covering well over 25 years, and Bernie was a great shining star in it. I shall always treasure golden memories of him. And of my visits to your home.

I liked him enormously as a person and a friend; and I loved his work. To me he was one of the very top cartoonists in *The New Yorker*. His drawings always had a rare stylish elegance, and the sophistication of his art was matched by his brilliant, sophisticated ideas. And his cartoons always made me laugh. Nothing remotely as good is being published in the magazine today.

I am so glad that we kept in touch (a measure of our friendship), with you also, dear Rhoda, and I always looked forward to receiving from the Schoenbaums the lively and bracing cartoon card every New Year. Of course, I have kept all of those. Please continue to keep in touch, and I hope we shall meet again some day. And I shall never forget Bernie.

With love from your friend,
Alex

Obituary written by
Times Of London reporter

TIMES OF LONDON

Bernard Schoenbaum

October 6 2010 12:01AM

For almost 30 years Bernard Schoenbaum's work graced the pages of *The New Yorker*. What amused and sometimes discomfited his readers was a reflection of their own attitudes, ambitions, prejudices and conceits.

His subjects, or perhaps more accurately his targets, were drawn from the liberal East Coast and yet the traits he exposed — prosperous, knowing, ruthless, ironic, combative, crestfallen and cute — are universal ones. Schoenbaum and his contemporaries, Frank Modell, James Stevenson, Robert Weber and Lee Lorenz, were attuned to every nuance and quirk.

Born in Manhattan in 1920, Bernard was the elder son of Russian-Jewish émigrés. His younger brother Sam was a distinguished Shakespearean scholar. He was educated in the Bronx and at the Parsons School of Design, New York. Much of his career was as a freelance advertising illustrator but when his wife took a job as a librarian he was able to devote himself to cartooning. His other endeavours included teaching the figure, life drawing, portrait sketching, oil painting and watercolours. He also worked as a portraitist on cruise ships.

He contributed his first drawing (as *The New Yorker* preferred to call them) in 1974, when the celebrated William Shawn was still editor, and Lee Lorenz the arts editor. He was to contribute 463 cartoons to the magazine. He also contributed to *Barron's* and *The Wall Street Journal*.

Some of his earliest drawings and a sprinkling of all his work were captionless. His approach was literal while his style was a soft, fluid line and wash. He captured a northeastern knowingness; a world of men in tweed sports jackets, soft plaid hats and bad haircuts such that the reader would be taken in immediately and ready to laugh even before coming to the caption.

His cartoons embraced the world of parties and romance, commerce and employment, parents and children. The children were so worldly: a young boy says to his father who is reading his son's school report, "It's just a correction. The fundamentals are still good"; a little girl in bed talking to her father who has read her a fairytale, "It sounds a little too perfect. What's the downside?"; while another little girl says to her mother as they confront each other over a broken biscuit jar in the kitchen "Circumstantial. You haven't proved linkage."

Schoenbaum was as sharp in the office — an executive to others meeting around a table: "To pacify our shareholders, it's been suggested that one of us goes to jail." One businessman to another in a plush office says: "I'll level with you, Charlie. I'm going to let money get in the way of our friendship." A suited man at his desk on the phone says: "Joyce, I'm so madly in love with you I can't eat, I can't sleep, I can't live without you. But that's not why I called."

And the enduring issue of matrimony — a woman to a man at a smart restaurant: "Is this a real proposal, or are you off your medication?"; and a man to a woman as he proposes to her in a restaurant: "Say yes. I need a win."

His last cartoon, published in 2002, rather fittingly depicted two angels in Heaven; one saying to the other: "At least there's one place that's not youth-oriented."

As *The New Yorker's* current cartoon editor, Bob Mankoff, observed: "He was a sweet and gentle man. His humour did not look down on people, just a bit sideways."

Schoenbaum is survived by his wife, Rhoda (whom he married in 1948) and their three daughters.

Bernard Schoenbaum, cartoonist, was born on August 8, 1920. He died on May 7, 2010, aged 89

Obituary written by
Bruce Weber for
The New York Times

Bernard Schoenbaum, 89, New Yorker Cartoonist

By BRUCE WEBER

Bernard Schoenbaum, who in hundreds of cartoons in The New Yorker needled the relatively affluent, the media-conscious, the irony-besotted and the socially competitive — in other words, the readers of The New Yorker — died on May 7 at his home in Whitestone, Queens. He was 89.

The cause was cancer, said his daughter Joyce Dara. He also had a home in West Palm Beach, Fla.

Mr. Schoenbaum spent much of his professional life as a free-lance commercial illustrator, working for advertising firms. But in the 1970s, after his wife began working as a librarian, he was able to shift his emphasis to his first love, cartooning. Between 1979 and 2002, Mr. Schoenbaum found a regular outlet for his work in The New Yorker, which published more than 300 of his works.

His style of drawing was straightforward, more literal than suggestive, often depicting well-fed-looking figures in settings — business offices, restaurants, well-furnished apartments — that would ring with familiarity to upper-middle-class sophisticates.

They are people who have money and worry about it, who have had some success and worry about it, who have pets and children and worry about them. Indeed, Mr. Schoenbaum often poked fun at adults by having children ape their parents. "Say, Dad, think you could you wrap it up?" a child being read a bedtime story says, in a 1994 cartoon. "I have a long day tomorrow."

Sometimes his cartoons were especially topical; in 1986, as the

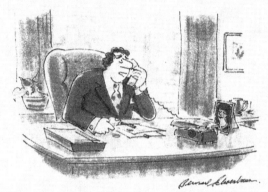

"Joyce, I'm so madly in love with you I can't eat, I can't sleep, I can't live without you. But that's not why I called."

BERNARD SCHOENBAUM/NEW YORKER COLLECTION/WWW.CARTOONBANK.COM

Above, a 1988 Bernard Schoenbaum cartoon from The New Yorker. Left, Mr. Schoenbaum in 2007.

Sometimes his work caught perpetual social truths with sardonic acuity; in an unpublished cartoon, for example, a well-dressed man and a woman sit holding hands at a restaurant table. "Let's get married," the man says. "I'm tired of being charming."

Sometimes Mr. Schoenbaum simply scratched his head at human folly; in a 1988 cartoon, two men are sharing a jail cell, and one of them laments, "All along I thought our level of corruption fell well within community standards."

Mr. Schoenbaum was born in Manhattan on Aug. 8, 1920, and grew up in Manhattan and the

savings and loan crisis was snowballing, he depicted a man carrying a briefcase walking past a bank that had a sign in the window reading, "Keep the Faith."

A comic specialist in the foibles of the well-to-do.

Bronx, where his father, Abraham, a Jewish immigrant from Russia, started a number of small businesses. He attended James Monroe High School in the Bronx and the Parsons School of Design. In addition to The New Yorker, his work appeared in a number of publications, including Barron's and The Wall Street Journal. For years, Mr. Schoenbaum also worked as a portraitist on cruise ships.

"Hundreds of his portraits are spread around the world," said his wife, the former Rhoda Abrahams, whom he married in 1948. In addition to her and their daughter Joyce, who lives in Santa Monica, Calif., Mr. Schoenbaum is survived by two other daughters, Audrey Tufano of East Meadow, N.Y., and Laura Schoenbaum Rothenberg of Shirley, N.Y.; and a granddaughter. His brother, Samuel Schoenbaum, a noted Shakespeare scholar, died in 1996.

Mrs. Schoenbaum recalled that she met her husband when she was 17 and went to a dance at the 92nd Street Y in Manhattan, accompanying a friend who wouldn't let her stay home.

"I was into the books," she said. "I said, 'I don't go to dances.'"

Three years later, she married the young man she met there.

"We danced the polka," Mrs. Schoenbaum said.

Obituary written by
Terence Towles Canote in
A Shroud Of Thoughts

A SHROUD OF THOUGHTS

DEDICATED TO POP CULTURE IN ALL ITS FORMS

Justice League of America	**Award Winning Cartoonist**
Full Cast, Sound Effects and Music! A Movie In Your Mind	Zany Cartoonist Illustrator for Award Winning Magazine Illustration

WEDNESDAY, MAY 19, 2010

New Yorker Cartoonist Bernard Schoenbaum Passes On

Bernard Schoenbaum, who created hundreds of cartoons for *The New Yorker*, passed on May 7. He was 89 years old. The cause was cancer.

Bernard Schoenbaum was born in New York City and was raised in Manhattan and the Bronx. He attended James Monroe High School in the Bronx. He received his training in art at the Parsons School for Design.

Much of Mr. Schoenbaum's career was spent as a freelance commercial artist, although he had long wanted to be in a cartoonist. After his wife took a job as a librarian, Mr. Schoenbaum devoted more of his time to cartooning. From 1979 to 2002 he began contributing cartoons to *The New Yorker*. Mr. Schoenbaum's cartoons lampooned the rich, the socially conscious, and the upper classes in general. He could be topical, but more often than not he simply pointed out the ugly truths in society and the follies of being human. Mr. Schoenbaum also contributed work to *Barrons* and *The Wall Street Journal*.

Bernard Schoenbaum also worked creating portraits on cruise ships.

Over the years *The New Yorker* has featured some of the greatest cartoonist of all time. Charles Addams, Edward Gorey, William Steig, and James Thurber among them. Bernard Schoenbaum ranks in their number, not simply because he was published in *The New Yorker*, but because he had the same incredible level of talent. He was among the funniest and wittiest cartoonists to ever grace *The New Yorker*, with a sharp eye for basic human nature and a sense of humour that was often sardonic. With Bernard Schoenbaum's passing, we have lost one of the true greats of cartooning.

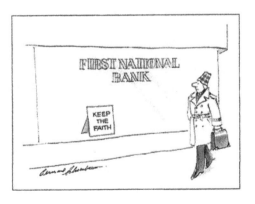

Bernard Schoenbaum's
Cartoons in Books

Titles	Pages
All You Can Eat: A Feast of Great Food Cartoons	unpaged - one
Art and Artists: New Yorker Cartoons from The Melvin R. Seiden Coll.	78, 00
Barrons Book of Cartoons	26, 30, 33, 40, 53, 75, 77, 85, 96
Books Books Books: A Hilarious Collection of Literary Cartoons	unpaged- three
Cats Cats Cats: A Collection of Great Cat Cartoons	16, 26, 55, 67, 83, 97,136, 159, 193, 200, 201, 211, 234
Dogs Dogs Dogs: A Collection of Great Dog Cartoons	unpaged - twenty cartoons
Fathers and Sons: It's a Funny Relationship	unpaged - two
Golf Golf Golf	66, 92, 96
Ho Ho Ho: A Stocking-Full of Christmas Cartoons	unpaged - two
Lawyers Lawyers Lawyers: a Cartoon Collection	67, 00
Moms Moms Moms: A Mirthful Merriment of Cartoons	unpaged - two
Movies Movies Movies: A Hilarious Collection of Cartoons	10, 14, 32, 60, 103
Now That You Can Walk, Go Get Me A Beer: A Book for Dads	unpaged - two
Play Ball: An All Star Lineup of Baseball Cartoons	unpaged - three
The American Cartoon Album	unpaged - four
The Art in Cartooning	160, 207
The Complete Cartoons of The New Yorker	400, 458, 501, 516, 539, 566, 583 plus 450 on disc
The New Yorker 75th Anniversary Cartoon Collection	28, 146, 181, 186, 221, 229, 247, 249, 279
The Big New Yorker Book of Cats	72
The New Yorker Book of Baseball Cartoons	1
The New Yorker Book of Business Cartoons	94, 110
The New Yorker Book of Cat Cartoons	38, 68, 84
The New Yorker Book of Dog Cartoons	11, 44
The New Yorker Book of Kid Cartoons	30, 84, 125
The New Yorker Book of Literary Cartoons	75, 89, 101
The New Yorker Book of Money Cartoons	13, 77, 89, 98
The New Yorker Book of Political Cartoons	3, 29, 96, 110
The New Yorker Book of Teacher Cartoons	42, 55, 57
The New Yorker Book of Technology Cartoons	8, 80
The New Yorker Book of True Love Cartoons	36, 100
The New Yorker Cartoon Album 1975-1985	unpaged - four
The Wall Street Journal Carton Portfolio	unpaged - one
The Wall Street Journal Portfolio of Woman in Business	59, 00
They'll Outgrow It and Other Myths: the Best Cartoons for Parents	82, 00
Why Are Your Papers in Order? Cartoons for 1984	unpaged - four
More Cartoons: Men & Woman & Children	10 thru 191

Printed in the United States
By Bookmasters